IMAGES
of America

GALENA

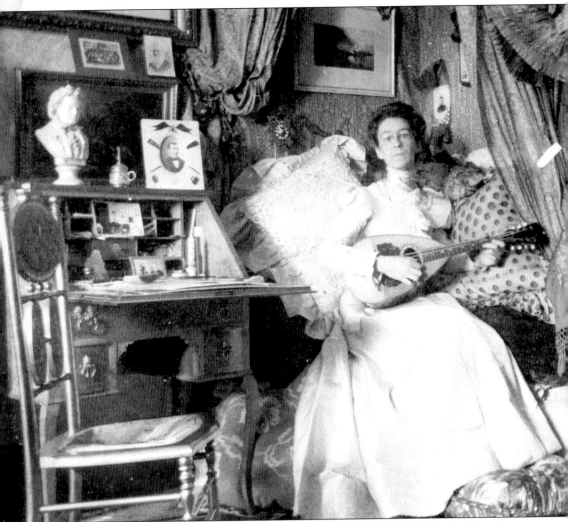

CHARLOTTE (MRS. DANIEL) EUSTICE. Mrs. Eustice strums her mandolin in the Turkish corner of her home at 513 Park Avenue about 1890. When new foreign and exotic countries were discovered during the last half of the 19th century, the Victorians became fascinated with anything that represented them. Drapery, shawls, cushions, divans, and floor pillows were among those items that helped create a Turkish or an Oriental corner. This photo illustrates that many Galenians decorated their homes in the latest style. (Photo Mueller Collection.)

On the cover: This c. 1910 photograph features Badminton and watermelon at the Galena Country Club, 300 Third Street. (Photo Mueller Collection.)

IMAGES
of America

GALENA

Diann Marsh

in cooperation with the Galena Historical Society and Museum

ARCADIA

Published by Arcadia Publishing
Charleston SC, Chicago IL, Portsmouth NH, San Francisco CA

Printed in the United States of America

Library of Congress Catalog Card Number: 2004117624

For all general information contact Arcadia Publishing at:
Telephone 843-853-2070
Fax 843-853-0044
E-mail sales@arcadiapublishing.com
For customer service and orders:
Toll-Free 1-888-313-2665

Visit us on the Internet at www.arcadiapublishing.com

To my husband of over fifty years and the father of our seven children.
We share a love of history and of Galena.

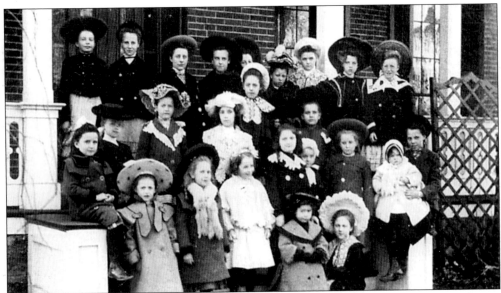

PORCH POSE. A group of young children and proper ladies pose on the porch of an elegant mansion about 1910. Wide double doors, topped with a segmental stone arch, pierced railings, and Tuscan columns indicate that the house was built around 1850. Note the elaborate trellis to the right side of the steps. (Photo Galena Historical Museum.)

CONTENTS

ACKNOWLEDGMENTS

In a city with a history as rich as Galena's, there are lots of people who are dedicated to studying and preserving various segments of the city's past. Many have contributed to this book with patience, kindness, and knowledge.

First of all is Daryl Watson, Director of the Galena Historical Society and Museum, without whom this book would not have been possible. Alice Toebaas and Nancy Wolfe, museum staff, have provided the use of the museum files, as well as encouragement. Jaime Dimke, Terry Miller, and Dan Tindell of the Illinois Historic Sites Office have gone out of their way to be cheerful and helpful while providing photographs and information. Thanks to the staff of the County Records Office, the Alfred Mueller History Room at the Galena Public Library, with curators Steve Repp and Scott Wolfe, is a wonderful source of information and records. Steve's encouragement and jokes kept my spirits up. Barb Tousey has indexed many of the history room materials, and continues to do so. There are those who have already done so much to record Galena's rich history, including Alfred Mueller, Tacie and Pete Campbell, and Marge Smith. Others deserving mention include Pat Richardson, Barb Price, Delores Nack, Bill Butts, Kathleen Meyers, Heidi Hagen, Nancy Breed, Kathi Kern, Lonna McDermott, Bob Spofford, Bob and Donna Spurr, Sandy Winge, Jim and Marie Nadeau, Wendy Heiken, Lori Hatten, Charlotte Kennedy, Richard Burlingame, Odd Fellows, Jacque Dyrke, Ralph Benson, Dick Vincent, and many friends and neighbors. This is their book, too.

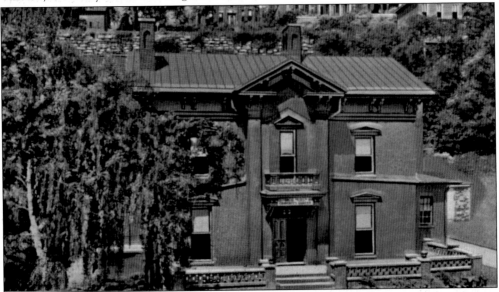

THE GALENA HISTORICAL SOCIETY. The society occupies a grand Italianate mansion built by Daniel Barrows in 1858. In 1922, the Wildey chapter of the Odd Fellows bought the building and enlarged it, creating two large, high-ceilinged halls at the back. It became Galena's historical museum in 1938. Full of unique and significant historical treasures, it is located at 211 Bench Street and is open seven days a week from 9:00 a.m.–4:30 p.m. (Photo Spurr Collection.)

FOREWORD

Galena is a special place. It has warmth, character, history, and constancy. Walk down Park Avenue, for example, and in seven short blocks you'll see 150 years of architectural styles. You'll also walk past homes and families. Rich and poor, young and old, new-comers and old-timers . . . they're all here. Playing, working, sitting on the porches and walking down the sidewalks. Norman Rockwell would have loved it.

There's a sense of place about Galena. Even the name, Latin for lead sulfide, evokes earthy images of rugged miner and frontier spirit. It started with the 1820s when crude log cabins sprung up along the river, and then up and down the hillsides. Then came larger homes, many of that soft, orangish brick that gives Galena such a pleasant patina. During the boom years houses sprouted from every crook, cranny, and crag like so many mushrooms in a forested glen. One early traveler likened the scene to a giant flinging handfuls of houses against the hillsides, and the mud (for which Galena was so famous) causing them to stick there.

The streets are equally quaint. Narrow, crooked, winding . . . and always rutted and challenging. Some say they haven't changed.

The river has changed. Once wide, deep, and proud, it was the town's lifeblood. Huge steamboats, some over 230 feet long, plied its waters. It's all a distant memory now. Too much soil washed down the upper tributaries, loosened by the miners and then farmers. Galena, which had been the largest port north of St. Louis in the 1830s, 1840s, and 1850s, became simply another local trade center.

But the town persevered. Trade continued, albeit on a smaller scale. Homes continued to be built, at least a few of them. And families continued to work and play. They came to love their town and to cherish its history.

Today, Galena is booming again, but not with miners, steamboats, and farmers. Now it is tourists—over one million a year—trying to get away from it all. They are captivated by this storybook place. It's a page from a past time, different, unique . . . and yet real. Some are trying to find their roots, others are seeking to put down new ones. Mix these with those who never left their roots and you truly have a most eclectic place.

This is the place to which Diann Marsh came. She and her husband settled on Park Avenue and are now permanently attached. A thorough researcher and gifted writer, she seeks to illuminate the faces and families that gave life to this community and were the caretakers of its architectural heritage.

In her quest, Diann has left no brick unturned. She has used freely the extensive resources of the Galena Historical Society and Museum: old photographs, tax records, censuses, and so much more. The Historical Collections Room of the Galena Public Library has helped, too, with all of its materials. Other places have pitched in as well.

Sometimes the families themselves helped most. Both new and old, they shared their thoughts, memories, and histories. And through Diann, they are now sharing their experiences with us. That's the way it should be, especially for a special place like Galena.

Daryl Watson
Executive Director
Galena Historical Society and Museum

INTRODUCTION

Every house has a special story to tell—if only we will listen. Memories of the houses in which we were born and/or raised remain with us forever. It may have been the place where your mother cooked your favorite dishes and taught you how to sew. Perhaps your father helped you build a special tree house and held onto the seat while you learned to ride your first bike. The family gathered around the piano to sing Christmas carols or the latest musical favorites and your best friend lived down the block. Sometimes the stories were sad, like when a favorite relative died or you broke your arm while trying out your new skates on the driveway.

This is not a book that emphasizes architectural styles, although the size, massing, materials, and design of each house often tell us much about the people who lived there. In this book, architecture is usually mentioned as part of a larger history.

Galena's first permanent homes were log cabins and miners' cottages. Many still exist along the streets, particularly on the west side, between Gear and Franklin streets. Even though they are usually small, they are strong and proud and made of sturdy brick. Most have been restored into cozy homes, but a few are boarded up, in need of repair, and others have disappeared altogether. Some of the miners had large families, while others were bachelors.

Visitors notice the mansions, usually made of brick and resplendent with ornate wood trim. These mansions were a badge of success for their often newly wealthy owners. Among them were steamboat captains and owners, builders, bankers, wholesale grocers, jewelers, and capitalists. Such houses required several servants, including stablemen, to keep them running.

Then there are the houses in between. Attractive and eye-catching, they were built in styles from the early Greek Revival and Italianate through the later Queen Anne, Craftsman and Colonial Revival. The individual character of each house is exhibited in the rich panorama of styles you see as you walk along each street. These homes have their own special stories to tell and provide fond memories to the families who lived there.

By the 1950s, 1960s, and 1970s, many of Galena's buildings and homes were in a sorry state. Ralph Benson remembers that when he returned after World War II, many of Galena's buildings were in need of major repair. These homes and buildings have been brought back to life one by one.

The historic preservation movement began in Galena when a handful of local men and women realized the significance of the town's historic buildings. The local historic district and Historic Advisory Board were established by an innovative ordinance in 1965. The district was placed on the National Register of Historic Places in 1969. We are now seeing the results of those far-thinking ideas. Galena is sometimes called "the town that time forgot," creating the ideal situation for successful historic preservation activities.

You will see houses that are so much more than brick, mortar, and wood. They are the reminders of the souls who were born, lived, and died within their walls, remembering both the happy and sad times. We hope you will enjoy your peek into Galena's family homes and tuck them away in your memory.

One

A Stroll Down Park Avenue

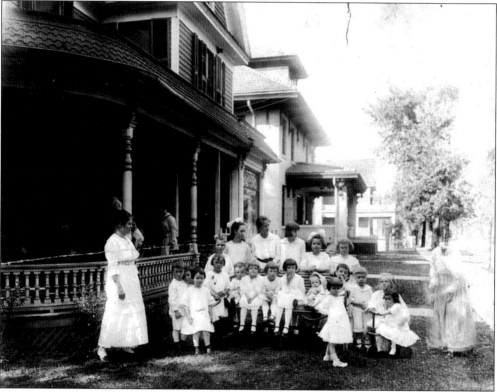

The young members of a Sunday school class, dressed in their summer's best, pose on the front lawn of the house at 515 Park Avenue. Elm trees once lined Park Avenue, creating a rich canopy of green. Park Avenue, originally named Second Street, is lined with the homes of Galena's upper middle class built during the years before the turn of the century. In the late 1820s and 1830s, the street was the site of a few log cabins. Major development began in the 1850s, with a "building boom" taking place in the late 1860s–1880s. In the 1880s and 1890s, approximately a dozen houses in another style, the Queen Anne, added a new look to the neighborhood. When the Craftsman Bungalow gained popularity from 1910–1925, several of the earlier houses were clad in stucco on the exterior and modernized to fit that style. The name was changed to Park Avenue from Second Street when Grant Park was created in 1891. When you think of Park Avenue, think of the many families who spent their lives here. (Photo Mueller Collection.)

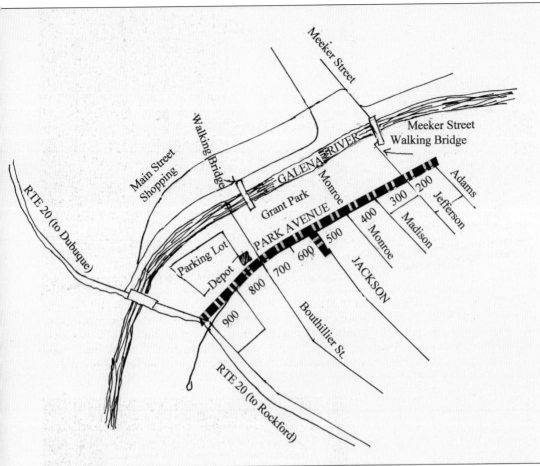

PARK AVENUE MAP. The Park Avenue tour starts at the Old Depot, one block off of Route 20, at the east end of the Einsweiler Bridge. Note that the house numbers are in reverse order, with the 700 block at the beginning of the tour, and the 200 block at the north end. As you go north, you will see the East Galena Hall on your left and the Water Works across the street. A short detour, onto Jackson Street, leads to two houses that are listed. The tour takes up again in the 500 block of Park Avenue. Two walking bridges lead to downtown. The bridge from Grant Park leads to Commerce Street and the Post Office, while the Meeker Street Walking Bridge, one block west from Jefferson Street, leads to the north end of the business district.

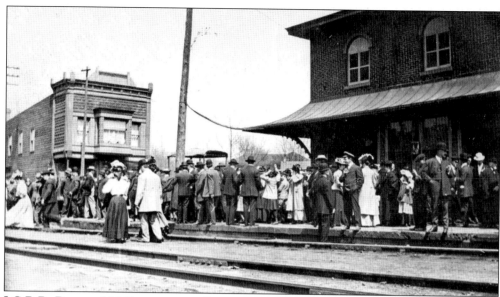

I.C.R.R. DEPOT: 101 BOUTHILLIER STREET. Constructed at a cost of $8,000 in 1857 for the Illinois Central Railroad, the two-story red brick depot has been restored to its original elegance and is now in use as the visitors' center and houses the offices of the Chamber of Commerce. Ralph Benson purchased the building for $35,000 in the 1970s, repaired the roof, brick work, and interior, and gave it to the city for just the cost of repairs. (Photo Mueller Collection.)

CHICAGO NORTHWESTERN DEPOT: 100 BOUTHILLIER STREET. Three years ago, this small, vacant building was considered by many to be beyond repair. Along came the Carters, who, recognizing its unique architecture, carefully restored it in 2003. In 1899, Otto Salloman built the building with plans for an elegant restaurant, but ran out of money. He lived upstairs and rented the building to the Chicago Northwestern Railroad depot in 1900. (Photo Marsh Collection.)

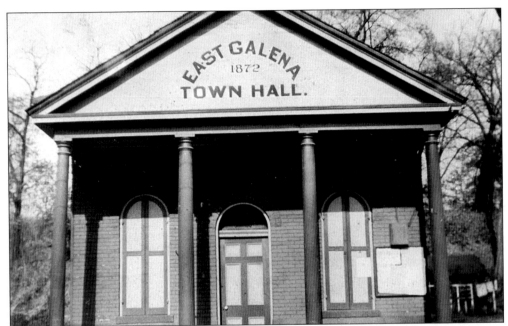

EAST GALENA TOWNSHIP HALL: 725 PARK AVENUE. The hall has changed little since it was constructed in 1871 in the Greek Revival style. The *Galena Gazette* of August 11, 1871 tells us, "A new town hall for East Galena is being erected near the depot. It is brick and a neat and convenient structure. Such an institution (voting center) was badly needed in town." The recently rejuvenated building is still used primarily as a voting site. (Photo Mueller Collection.)

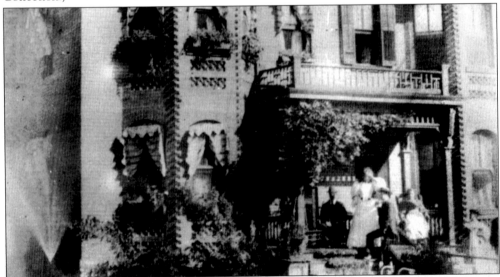

STROHMEYER'S DOUBLE HOUSE: 719–721 PARK AVENUE. The year 1886 was an exciting one for the Strohmeyer Brothers. They built both this double house and the boot and shoe factory next door. They had only to cross the lawn to get to work each morning. Joseph, who lived in the south half, ran the shoe factory office. Anton, superintendent of the work force, occupied the north half of the duplex. The present owners recently replicated the original front porch and restored the interiors. (Photo Mueller Collection.)

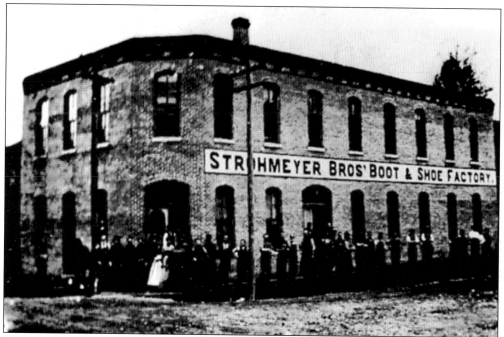

STROHMEYER BROS. BOOT AND SHOE FACTORY: PARK AVENUE AT JOHNSON STREET. In 1890, the bustling Strohmeyer Boot and Shoe Factory, built in 1886, had 30 employees, two-thirds of which were women. The first floor held the office, packing room, sole leather, and finishing rooms, while the second floor was "like a bee hive, with its throng of busy men and women at work on all kinds of footwear." By 1900, the building had been converted to apartments. (Photo Mueller Collection.)

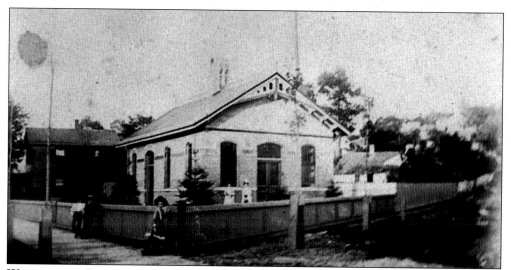

WATERWORKS BUILDING: 720 PARK AVENUE. Borders of stained glass, in the Eastlake style, add vibrant colors to the windows of the 1886 Galena Waterworks building. The tan brick borders are also Eastlake in character. The date, 1886, and the names of the responsible city officials are inscribed on the front gable. Since 1996, the building has been occupied by the Galena-Jo Daviess Visitors and Convention Bureau. (Photo Galena Historical Museum.)

HOLTKAMP HOUSE: 714 PARK AVENUE. Two generations of the Holtkamp family lived in this house from the time Henry and Clementine built it in 1872, until the 1930s. Henry, a cigar maker, served in the Union Army and returned disabled. Henry Jr. was also a cigar maker. The unique porch posts are typical of those used in the early 1870s, and appear be original. The house has been beautifully restored. (Photo Galena Historic Sites Office.)

KRAEHMER HOUSE: 712 PARK AVENUE. Oscar and Bertha Kraehmer built this classic Victorian home in 1891. The Kraehmer Optical and Jewelry Company occupied one half of his store on Main Street, while the Kraehmer Music Company sold pianos, organs, and musical instruments in the other half. The original Victorian porch was redesigned in the Colonial Revival style in the 1910s. (Photo Galena Historic Sites Office.)

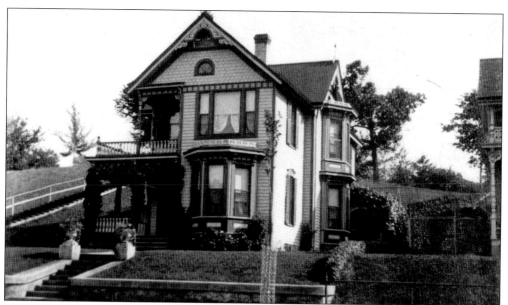

SINIGER HOUSE: 710 PARK AVENUE. William and Henrietta Siniger built this Queen Anne home in 1891. The only graduate pharmacist in this part of the state, William purchased the Newhall Drug Store, founded in 1832. The house was inherited by their daughters, Henrietta, who gave piano lessons in the living room, and Anita, who worked at the bank. Neither married. The house was remodeled with a Craftsman influence in the 1910s. (Photo Galena Historic Sites Office.)

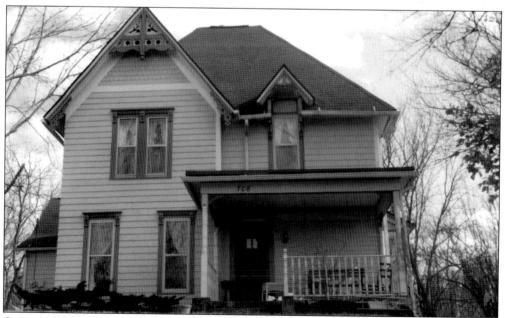

GLESSNER HOUSE: 708 PARK AVENUE. Arthur Glessner built the house at the top of the hill for his widowed mother, Mary, in 1884. In the 1890s, he was the manager of the *Galena Gazette*. Mrs. Glessner, born in England, came to America at the age of nine. Stairs once led from Park Avenue to the house. Dick Vincent remembers when the neighborhood children sledded down the hill and clear across the street on a snowy day. (Photo Marsh Collection.)

PARK AVENUE TRIPLETS: 702, 704, AND 706 PARK AVENUE. When Otis Horton built these three houses in 1887, they looked like triplets, with similar setbacks, gables, porches, and footprints. Eventually 706 (far right) was turned into a Queen Anne with rounded porch. Its neighbor, 704 (center), was converted to a Craftsman Bungalow. Although 702 (on left) received new siding and an enclosed porch, it looks much as it did originally. (Photo Marsh Collection.)

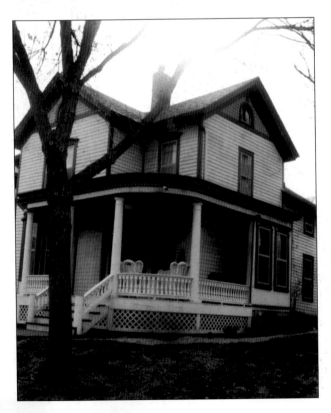

GRIBBLE HOUSE: 706 PARK AVENUE. Otis Horton built this 1887 house for use as a rental until John and Villa Gribble bought it in 1899. Gribble was listed as a commercial traveler in 1900, but by 1914 was the owner of the Gribble Advertising Co. Note the wrap-around front porch and slanted bay window that replaced the original full porch and created the Queen Anne appearance. (Photo Galena Historic Sites Office.)

KERZ HOUSE: 704 PARK AVENUE.
Paul and Eleanora Kerz are shown
on their wedding day, October 5,
1899. They moved into this house
immediately afterwards. Sadly, Eleanora
died in January of 1908, nine days
after giving birth to her 6th child.
The baby also died, and the two were
buried together. She left five motherless
children under seven years of age. Paul
raised them with the help of his sister,
Barbara Heid, who lived next door.
(Photo Kathy Kern Collection.)

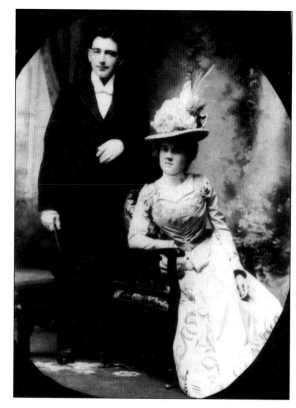

KERZ HOUSE: 704 PARK AVENUE.
Mrs. Henry Roberts purchased her
new house from builder Otis Horton
in 1887. In 1899, she sold the house to
Paul and Eleanora Kerz. A prominent
attorney, Paul was active in almost
every organization in town. Paul served
as city attorney for 15 years before
becoming a judge of the circuit court.
Before its Craftsman makeover, it was
similar to the house next door at 702.
(Photo Kathy Kern Collection.)

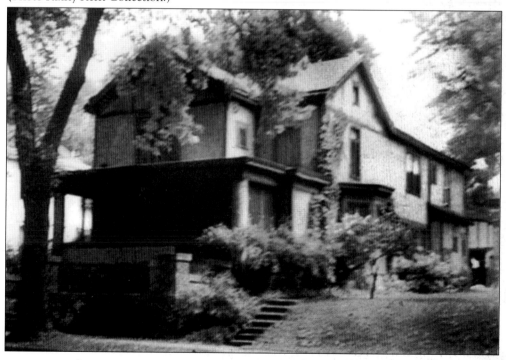

KERZ HOUSE: 704 PARK AVENUE. In 1916, Paul married Sylvia McKinney at Schererville, Indiana, and brought her to live in the house. In the early 1920s, the house was completely remodeled in the Craftsman style. The exterior was clad in stucco, a larger porch built, and decorative beams and brick entrance steps added. Tradition says that the architectural design was by a partner of Frank Lloyd Wright. Paul and Sylvia moved to Peoria in 1924. (Photo Kathy Kern Collection.)

HEID HOUSE: 702 PARK AVENUE. John Heid, a tinsmith and plumber, bought this house when it was new in 1887. John died in 1900 at the age of 44, and Barbara was left to raise their five children alone. Her brother and his wife, Paul and Eleanora Kerz, lived next door. Including the Kerz's five children, there were ten cousins living next to each other. It must have been fun! (Photo Galena Historic Sites Office.)

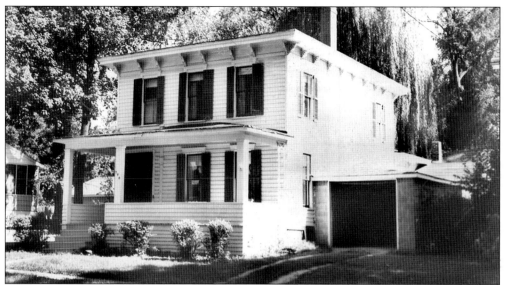

MOORE HOUSE: 700 PARK AVENUE. After Otis Horton built this house in 1887, he leased and then sold it to Thomas and Jessie Moore. They were the owners of the T. E. Moore Grocery Company, "dealer in staples and fancy groceries, fruit in season, and the sole agent in Galena for Chase and Sanborn's coffee." Note the graceful brackets lining the eaves. The Moores lived here for almost 50 years. (Photo Galena Historic Sites Office.)

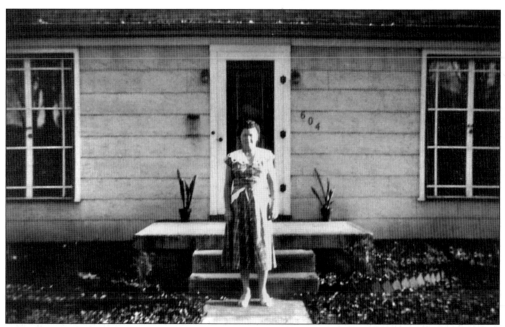

GABER HOUSE: 604 PARK AVENUE. Barbara Gaber poses in front of the house that she and her husband, Merle, built in 1947. Merle owned the Gaber Construction Company. From 1948–1951, he engineered the construction of the flood control levees and installed the big green gates. Their children were Barbara Gaber Price and Merle Gaber Jr. Minimal Traditional in style, it features horizontal massing and a low-pitched, side-facing gabled roof. (Photo Barbarann Gaber Price Collection.)

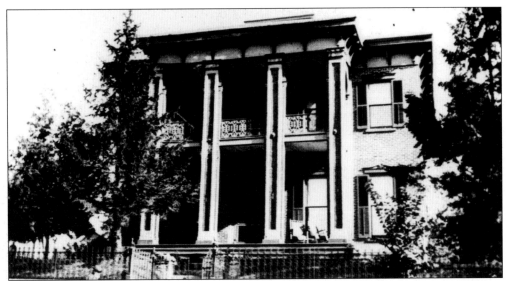

SMITH MANSION: 600 PARK AVENUE. The Orrin Smith House, built in 1852 in the Italian Bracketed style, cost more than $6,000 to build. Captain Orrin Smith amassed and then lost most of two fortunes in the panics of 1837 and 1857. Coming to the area in 1824, he started as a miner. In 1867, the Smiths sold the house to Thomas Leekley from Council Hill. He was associated with the Galena Woolen Mills. In 1888, the home was sold to Richard and Jane Barrett, who lived here with their two daughters. Richard was a wholesale grocer. (Photo Courtesy Galena Historical Museum.)

SMITH MANSION: 600 PARK AVENUE. In this photograph, the Orrin Smith mansion is to the right of Jackson Street (the light diagonal), the James-Bermingham House is to the left, and the Hoskins-Montgomery House is at the left border. A perfume factory once occupied the Smith mansion. In 1974, George Funke purchased the house and offering tours for one dollar per person. The house is in the process of being restored to perfection. (Photo Mueller Collection.)

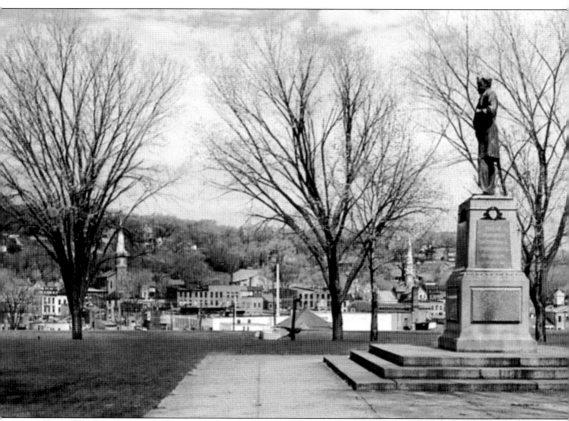

GRANT PARK: PARK AVENUE AT JOHNSON STREET. One of Galena's favorite historic sites, Grant Park spans two blocks on the west side of Park. It was the reason for changing the name of the street from Second Street to Park Avenue. The park plans were begun in May of 1890 when Herman Kohlsaat proposed a monument to General Grant and indicated his willingness to provide the bronze statue, to be created by Johannas Gelert of Chicago. He proposed this land be purchased by the City and made into a park featuring the statue, "where it will stand for ages, a constant reminder of the greatness achieved by General Grant, whose deeds it was to commemorate." Other features were soon added to the park. The Soldiers Monument was moved from Seminary Hill in 1891. The Ladies' Auxiliary raised the funds for the beautiful fountain that same year. The Victorian band stand was built in 1901. The pavilion was erected by James Ginn in 1917. In 1921, the concrete pagoda was built near Park Avenue. Volunteer gardeners keep the park filled with flowers. Along the hilltop, overlooking the Galena River, are benches from which to enjoy the idyllic view of the city. (Photo Galena Historical Museum.)

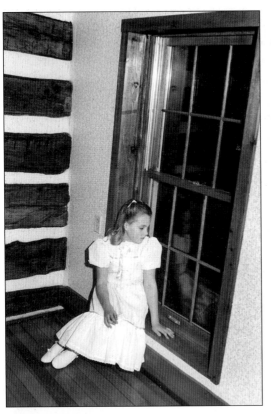

CONOUGHEY HOUSE: 218 JACKSON STREET. Turn right onto Jackson Street: Young Jamie Dimke sitting in the window of her home that was restored between 1974–1989. When her parents, the Robert Dimkes, bought the house, a few interior sections of the two-story log cabin were exposed. They were able to preserve the original log walls, windows, and floors in the two upstairs rooms. The rest of the house was restored to the period. It was built in 1837 by Michael Conoughey, a native of Ireland. (Photo Dimke Collection.)

DEAN HOUSE: 308 JACKSON STREET. Three members of the pioneer Bastian family pose near the neighborhood well in front of the cottage built in 1858 by William and Catherine Dean, the parents of six children. He was a steamboat man for many years. In 1895, Thomas Reynick, a railroad conductor, bought the house and lived here until 1913. The Bastian House is just out of the picture, to the right. (Photo Galena Historical Museum.)

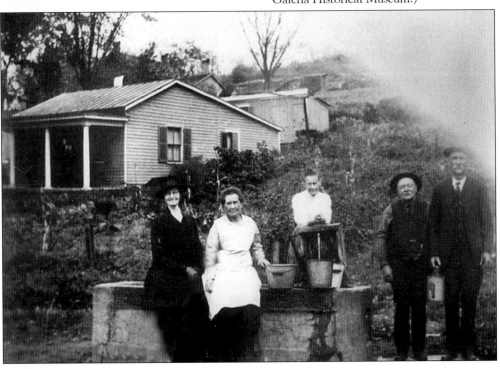

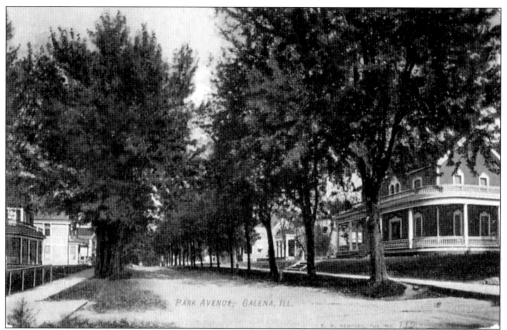

JAMES-BERMINGHAM HOUSE: 516 PARK AVENUE. Turn right back onto Park Avenue: James Edward James, a photographer, built the elegant house above (right) in 1870. Born in England, he served in the Civil War. He died in 1878, leaving his wife Kitty to raise four children and run the photography studio. In 1882, she sold the house to T. J. Bermingham, a member of the lumber firm of Hoskins and Company. Although the porches have been altered, the house still retains many of its original features. (Photo Spurr Collection.)

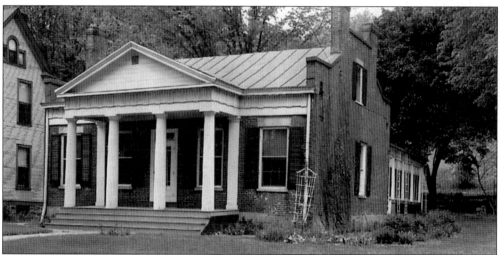

HOGE HOUSE: 512 PARK AVENUE. In 1842, Joseph Hoge built this classic Greek Revival style home. Two years later, Hoge, a lawyer, served a term in the U. S. Congress. Horace Houghton, editor and publisher of the *Galena Gazette,* was the second owner. Stewart Crawford, who bought the house in 1869, was a druggist. Kay Runde and her husband, the late Dr. Francis Runde, purchased the house in 1946. Registered on the H.A.B.S., it exhibits perfect classic proportions and has always been beautifully maintained. (Photo Galena Historic Sites Office.)

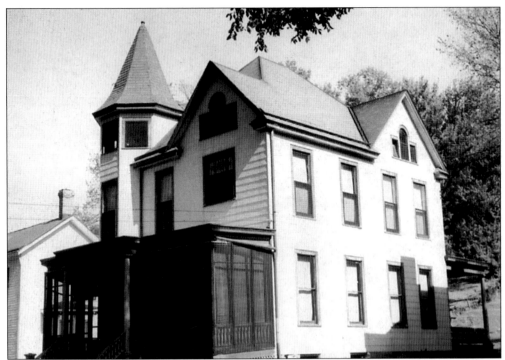

DAWSON HOUSE: 510 PARK AVENUE. In 1900, John and Bernice Dawson purchased this lot at 510 Park and made plans for a "fine residence with an ornate appearance." He was a commercial traveler. During World War I, Mrs. Dawson served as the county Directoress of Knitting for the Red Cross. In 1970, the Boyds bought the house. It has the elaborate interior woodwork often seen in Queen Anne houses. (Photo Galena Historic Sites Office.)

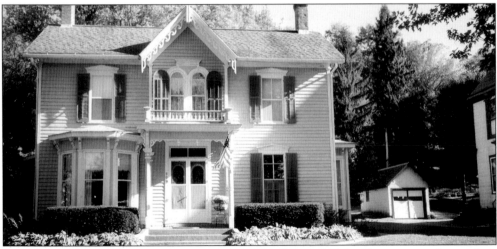

HORTON-WESTWICK HOUSE: 506 PARK AVENUE. Otis and Delia Horton moved into their new Gothic Revival home in 1884. Otis, who built at least a dozen houses on Park Avenue, was in the lumber business. Their only child, Anna, married Charles Westwick in a pink and white wedding in the parlor in 1898. Charles Westwick worked at the Galena Manufacturing Co. for almost 50 years. The Westwicks lived here until they moved to Flint, Michigan in 1945. (Photo Mueller Collection.)

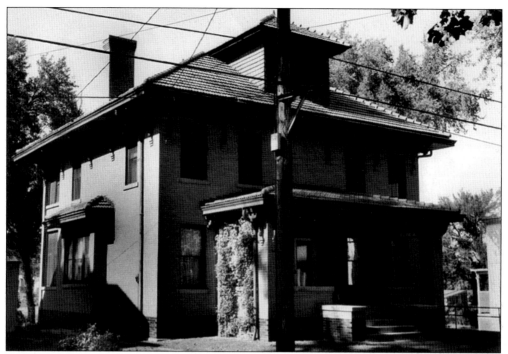

EUSTICE HOUSE: 513 PARK AVENUE. The Victorian house on this property, owned by Daniel and Charlotte Eustice, burned down in the 1910s and was replaced with this impressive brick Foursquare with Craftsman influences. In 1884, Daniel Eustice started work as a salesman for the Galena Axle Grease Co. and worked his way up to president. He invented several important machines. It was reported that when nationwide prohibition was enacted, it was "one of his happiest moments." (Photo Galena Historic Sites Office.)

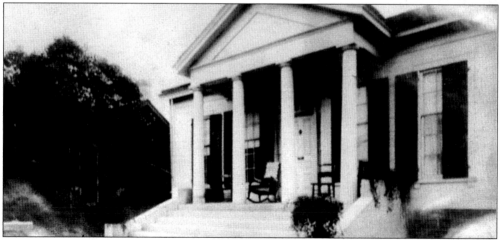

TELFORD HOUSE: 511 PARK AVENUE. Ann Telford was the first owner of the original section of this house, built in 1845 by William Telford. It was designed to face the river. In 1910 Sidney and Isophene Hunkins enlarged the house to three stories and installed the sparkling diamond-paned windows. The James Richardson family bought the house in 1952 and began a 15 year restoration. One of the highlights is the modern kitchen with log beams and rock walls. (Photo Richardson Collection.)

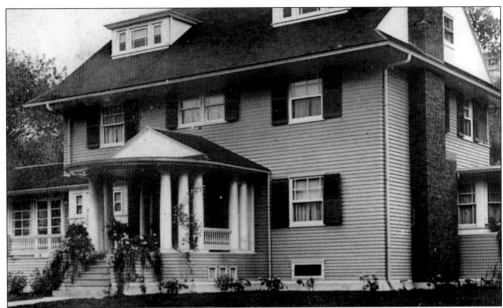

MONTGOMERY HOUSE: 500 PARK AVENUE. Charles White, a student of Frank Lloyd Wright, designed the impressive Colonial Revival house at 500 Park in 1908 for Eugene Montgomery. Montgomery was associated with the Hoskins Lumber Co. for over 55 years. He married Kate Hoskins in 1877 in Apple River. They moved to Galena in 1880. Their daughter, Harriett Priestly, and her husband, Harry, inherited the house. Purchased by Dr. and Mrs. Peterson in 1972, the house has always been beautifully maintained. (Photo Mueller Collection.)

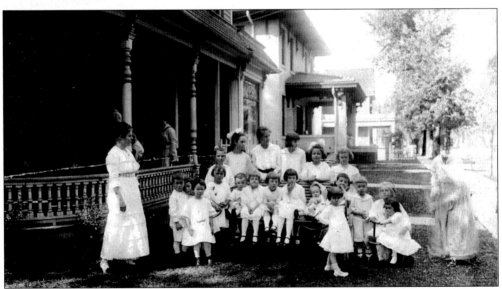

HOSTKINS-MONTGOMERY HOUSE: 515 PARK AVENUE. William Hoskins, the builder and first occupant of this lovely Queen Anne in 1884, owned one of the most successful and long lasting lumber companies in the area. In 1890, E. W. Montgomery, who was associated for over 40 years with the Hoskins firm, bought the house. He was active in many organizations during his life, including the Board of Education. The house was used in a movie, *Gaily, Gaily*, and a television show, *The Mississippi*. (Photo Mueller Collection.)

TRAVARTHEN HOUSE: 509 PARK AVENUE. An unidentified older gentleman and child pose down the street from the beautifully maintained Trevarthen House, seen in the background. It is remembered best for the Frank Trevarthen family, who occupied it from 1909–1977. Frank was raised on his father's farm in the Council Hill area. Both William and Lizzie, his parents, were from Cornwall, England and had eight children. Ellen Virtue, the daughter of David Virtue, lived here in the 1890s. (Photo Mueller Collection.)

MORE HORTON TRIPLETS: 505, 503, AND 501 PARK AVENUE. Otis Horton built these three houses in 1871. The first, 505, was built for John Gray, who lived in it for almost 50 years. He was a coal dealer, and later, a railroad agent. Horton built 503 and 501 as rentals. J. Hamilton and Lillie Smith occupied 503 and William Foyt lived at 501 for several years. Originally, the three houses were almost identical. While 503 (in the center) has changed little, 505 and 501 were remodeled in the Craftsman style. (Photo Marsh Collection.)

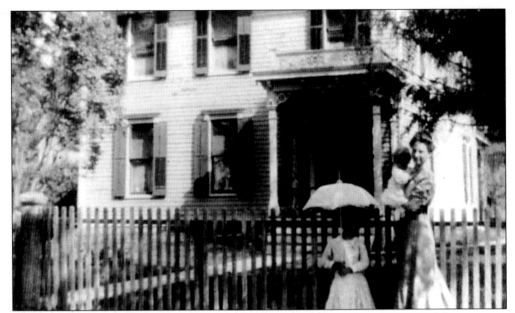

STEVENS-MILLHOUSE HOUSE: 408 PARK AVENUE. The original appearance of this spacious Italianate house is shown above. In the 1910s, it was clad in stucco and redesigned in the Craftsman Bungalow style. I. P. Stevens, a prominent Galena attorney, built the house in 1848 and lived here until 1909, when George and Ruby Millhouse purchased it. The Millhouses opened the Millhouse Brothers Hardware Store on Main Street in 1887. It remained in business for almost 100 years. (Photo Kim Kelly Collection.)

FARMER HOUSE: 402 PARK AVENUE. The restoration of the Farmer House by the current owners is indeed inspiring, as you can see from the 1964 "before" photo above. John Farmer, who built the house in 1858, came with his family from Ireland to Galena in 1850 and went into the grocery business. In 1878, the house was moved back 25 feet. His sister, Miss Annie, was the sole survivor of the Farmer family and lived here until she died in 1908. (Photo Galena Historic Sites Office.)

HODSON HOUSE: 411 PARK AVENUE. The Hodson House, in the center of this photo, is one of a handful of houses built between 1905–1908 in the attractive Dutch Colonial style. William Hodson was a partner with his brother, Thomas, in the law firm of Hodson and Hodson. By 1914, he had become a county judge. During the 1940s, the Bates family lived here. The present owners have completely restored the house, including replicating the original wood shingles in the gables. (Photo Spurr Collection.)

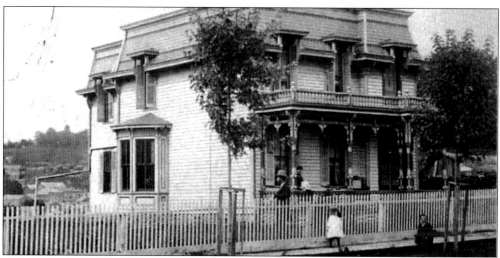

TELFORD-MILLHOUSE HOUSE: 407 PARK AVENUE. Harry Telford, one of Galena's foremost builders, really outdid himself when he designed this Second Empire beauty in 1879. Although the original Victorian porch was replaced by a Colonial Revival version, the house retains most of its architectural features. By the 1950s, George T. and Vera Millhouse, owners of the Galena Glove and Mitten Factory, lived here. Vera, who headed the library for many years, will be forever remembered for her involvement in historical activities. (Photo Mueller Collection.)

UNION HOTES: 401 PARK AVENUE. The Old Union Hotel, built in 1839, started out as a two-story log structure. It was later clad in clapboards, and then covered with wood shingles. It features 14 rooms and three original fireplaces. There were rooms for four guests, at $1.00 each per night, with meals costing 35 cents. After the building became a private residence, Adam Telford and Mrs. R. J. Edwards were two early owners. The house has been rehabilitated and was featured in the 2001 house tour. (Photo Galena Historical Museum.)

HORTON-EUSTICE HOUSE: 309 PARK AVENUE. Otis Horton, who built the house above in 1870, was a prominent builder and contractor. Charles and Anna Eustice bought it in 1910 and "modernized" the former Italianate house in the Craftsman style by stuccoing the exterior and adding a large porch. Charles was president of the Galena Axle Grease Company. His son, Palmer Eustice, also an executive with the company, inherited the house. His widow Eunice Eustice lived in the house until she died in 1989. At that time, the Carter Newtons purchased it. (Photo Sue Parsons Collection.)

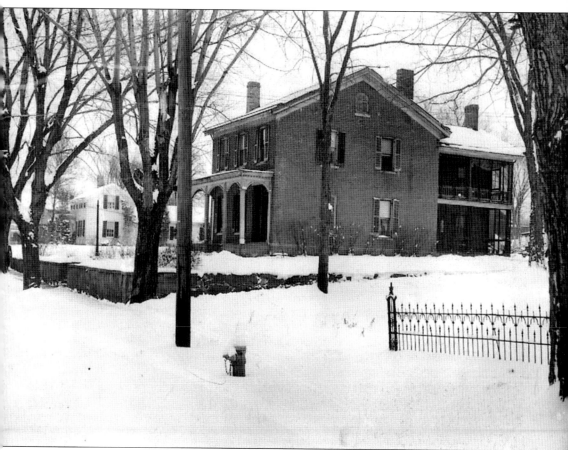

RAKOW HOUSE: 310 PARK AVENUE. When Frederick and Mary Rakow built this stately home in 1870, new houses were popping up on both sides of the 300 block. Frederick, who came directly from Prussia to Galena in 1854, made a respectable fortune in the pork-packing industry and the wholesale grocery trade. He was 55 when he died in 1875, leaving a wife and five children. The house remained in the family until 1912. Jim Vincent, son of Frank Vincent, who was born in the house and lived here until he went into the service, remembers this neighborhood fondly. Several years later, he and his wife, Mary Jane, came back to the 300 block when they bought the General Rowley House across the street at 305 Park Avenue. Adding another generation to the neighborhood history, their daughter, Sarah, and her husband, Carter Newton, bought the house across the street at 309 in 1989. The present owners of the Rakow house, who moved here in 1959, maintain it in perfect condition. The rich red glass transom above the front door is original. Red glass was the most expensive color because it had gold as an ingredient. (Photo Bob Spofford Collection.)

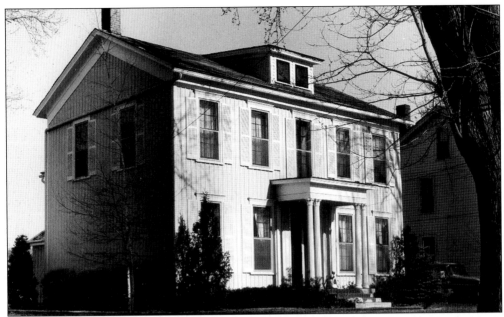

ROWLEY HOUSE: 305 PARK AVENUE. IN 1869, General William Rowley bought this 1867 house built by C. C. Sturtevant. Rowley, who arrived in Scales Mound in 1843, worked as a teacher. In 1861, he became an Aide de Camp to General Grant. Grant promoted Rowley to a general in 1864. After returning from the war, he served as circuit clerk, assessor and tax collector, sheriff, and county judge. (Photo Galena Historical Sites Office.)

GRAY HOUSE: 303 PARK AVENUE. In 1879, the *Galena Gazette* announced, "Mrs. Dorothea Gray built a two-story frame house on the lot next to General Rowley's on Second Street. . . . It is one of the handsomest residences in that quarter of the city." About 1915, Edward and Margaret Jeffrey, early owners of the City Hotel, purchased the house. Since then, the original full single-story front porch has been replaced by a portico. (Photo Galena Historic Sites Office.)

WELCOM HOUSE: 306 PARK AVENUE. In 1860, Otis Horton, who later built at least a dozen houses on Park Avenue, was the contractor for the Welcom House. Joseph Welcom was a blacksmith and wagon manufacturer at the Market Square, at Perry and Hill Streets. John and Josie Foster lived here in 1914. He was deputy county clerk. When Ella and Ruthie Knautz owned the house in the 1950s–1970s, their side porch was a favorite neighborhood hangout. (Photo Marsh Collection.)

SMITH-GLICK HOUSE: 304 PARK AVENUE. General John E. Smith, who came to Galena as a jeweler in 1836, was appointed Brigadier General by Grant in 1862. Jerome Smith, pilot of the boat, *City Belle*, lived here during the 1850s. By 1900, James McCabe, a retired farmer, was the owner. The classic brick house, covered with stucco in the 1910s, has been beautifully restored and the original brick exposed by Wayne and Doris Glick, who bought the house in 1970. (Photo Marsh Collection.)

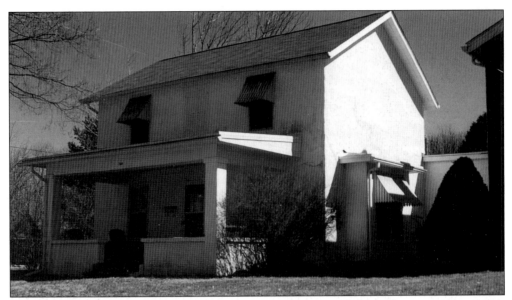

WARD HOUSE: 300 PARK AVENUE. Patrick Ward, a teamster, built the house at 300 in 1870. In 1900, the Wards were living here with their grown children, Julia, a school teacher, Frank, a railroad conductor, and Joseph, a grocer. The Ward heirs sold the house to the Hollingworths in 1977. Thus, the house has been home to just two families in over 130 years. It was stuccoed during the 1910s, a popular redesign that was Craftsman influenced. (Photo Marsh Collection.)

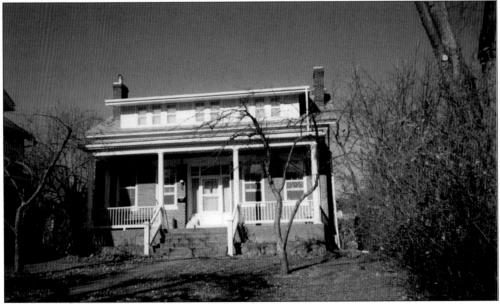

POTTS-SWING HOUSE: 301 PARK AVENUE. Built *c.* 1854, this brick Greek Revival home appears in the 1856 drawing of Galena by Whitefield. Charles Potts, who arrived in Galena in 1838, worked as a bookkeeper in the J.B. Grant Leather Store. He later operated a school for accountants, called the Galena Commercial Institute, in this house. In 1900, R.S. Bostwick, surveyor of customs, lived here. Stuccoed in the 1910s, it was restored to its original brick in the 1980s. (Photo Galena Historic Sites Office.)

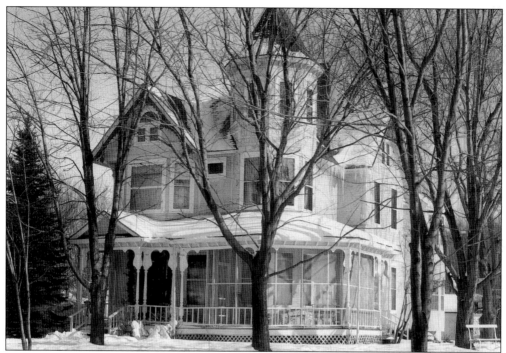

SAMPSON HOUSE (PARK AVENUE GUEST HOUSE): 208 PARK AVENUE. Replacing an earlier stone structure, the Sampson House was built in 1898 by Lucille Sampson. Barbarann Price, who lived here from 1957–1964, remembers the neighborhood fondly for its friendliness. "There were lots of children for ours to grow up with, and the families were all good friends who cared about each other. We always felt safe here, and there were many picnics and get-togethers." The house has been beautifully restored by the Fallbachers. John built the gazebo out of elevator doors from Chicago. (Photo Galena Historical Museum.)

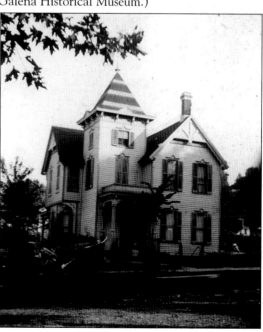

MITCHELL-TAYLOR HOUSE: 204 PARK AVENUE. An elaborate stained glass window in the Methodist Church was dedicated to Daniel Taylor soon after he died in 1913, a few days before his 84th birthday. A prominent lumberman and co-owner of the firm of Barrows and Taylor, Daniel was one of several Park Avenue homeowners who were involved in the lumber and building business. The Taylors purchased the house in 1899 from the estate of George Mitchell, who built it in 1886. (Photo Galena Historic Museum.)

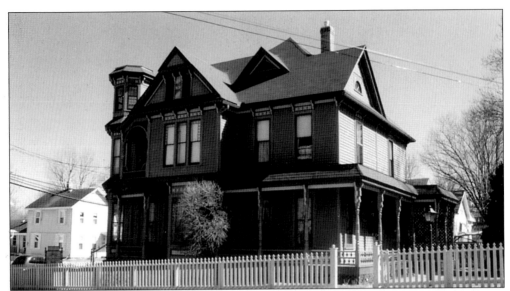

RIDD HOUSE: 200 PARK AVENUE. Another one of W.A. Telford's beautifully designed Queen Anne houses, the Ridd House was built for William and Louise Ridd in 1892. Starting his career as a sales clerk, William worked his way up to a managerial position in the J. Fritz Company, Sash and Door Dealers. He went on to become a wholesale grocer and traveling salesman. He died in 1914. Sadly, their only son William, who lived at home and took care of his mother, died at the age of 36, in 1916. (Photo Marsh Collection.)

REED AND HODSON HOUSES: 211 AND 209 PARK AVENUE. Note the similarity of these two houses, especially the tall narrow front windows, front façade design, and decorative features. Otis Horton built them in 1870. Early owners William and Catherine Reed, retired farmers, lived at 211 for many years before he died in 1886. Thomas Hodson, a lawyer, lived at 209 for over 40 years. In the 1880s, he was states attorney for the county. (Photo Marsh Collection.)

Two

VISITING
GENERAL GRANT'S
NEIGHBORHOOD

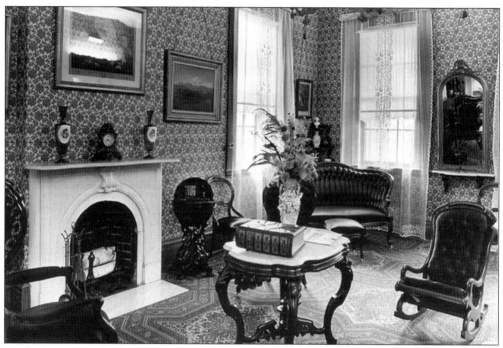

General Grant walked these streets, visited with his neighbors, and probably discussed politics with friends. He must have walked up and down Bouthillier Street often. Florence Bale tells this story: "During the early part of the war, it was hinted to him that some day he would be a candidate for high civic honors. He quietly answered, 'I would like to be Mayor of Galena, then I might get a sidewalk from my house to the depot.' When the city welcomed the returning hero, one of the arches over Main Street said, 'General, the sidewalk is built.'" Above is a view of the parlor in General and Mrs. Grants' home. The house has been restored as accurately as possible and contains much of the Grants' furniture, art, and accessories. Who was Bouthillier, and why was this street named after him? Francois Bouthillier, a Frenchman, was a roving trader who followed the Indians in the early 1800s and was seen in the Galena area as early as 1819. Settling permanently on the east side of the Fever (Galena) River in 1824, he opened a trading post where the Illinois Central Railroad Station is now located. He established the first ferry boat across the river. (Photo Galena Historic Sites Office.)

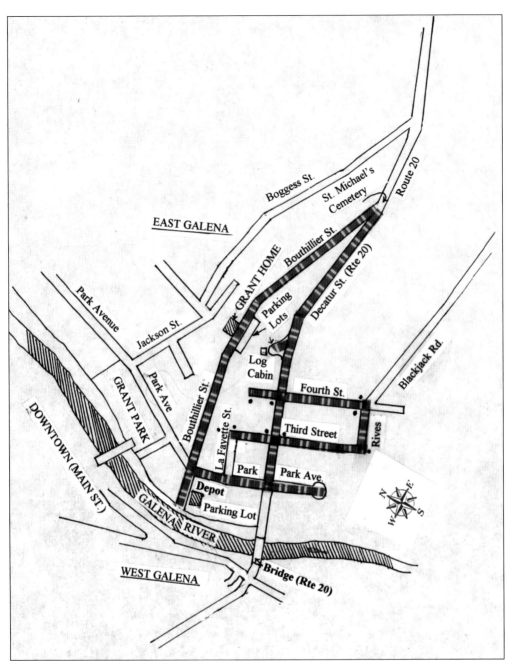

Tour of General Grant's Neighborhood. From the Old Illinois Central Depot, take Bouthillier Street east, up the hill. Grant's home, parking lot, and a small settlement of buildings owned by the state are just past the top of the hill. Continue east and turn right at Route 20 (Decatur Street) and head back west. The log cabin is in the Grant Home parking lot on the right side. Take Fourth Street south to Rives Road. Turn right and return to Route 20. Turn left on 20 to Park Avenue to see the three houses in the 1000 block of Park Avenue. Turn around and cross Route 20 to see the houses in the 900 and 800 blocks, returning to the Depot.

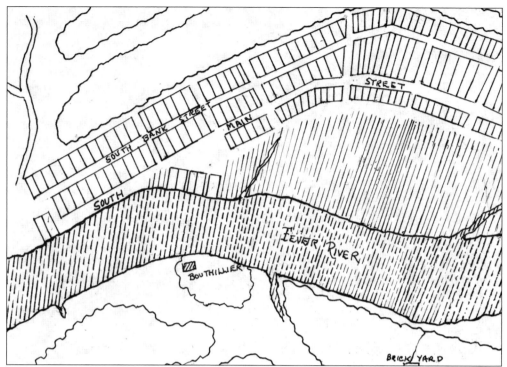

EARLIEST PLAT MAP OF GALENA. Imagine the east side of the river when it was populated with only a few log cabins and Francois Bouthillier's log trading post. Located where the Illinois Central Depot now stands, the trading post was one of the first buildings on the east side. The map shows Galena as it was when it was first laid out in 1826. Plats on the west side of the river surround a shallow basin. The east side had yet to be subdivided into separate lots. (Photo Galena Historical Museum.)

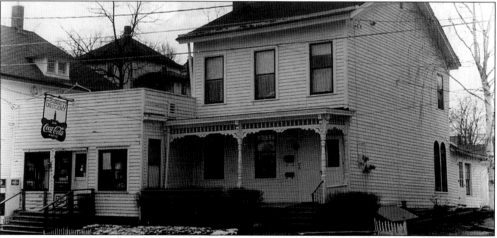

EAST SIDE GROCERY STORE: 207 BOUTHILLIER STREET. Neighbors fondly remember the East Side Grocery that was added to the east side of the 1880s house above in 1936 by Cecelia and Nell Creighton. Children could walk to the store to buy candy and treats, and adults could buy homemade potato salad, breads, cookies, and custom sliced meats. Once an important part of the neighborhood, it closed in 1979. (Photo Galena Historic Sites Office.)

CORCORAN HOUSE: 305 BOUTHILLIER STREET. Patrick and Josephine Corcoran built this classic Colonial Revival home in 1887. Of Irish ancestry, Patrick came to Galena from New York. A railroad engineer and fireman, he married Josephine in 1882. They had two children, Walter and Katherine. In 1914, the parents were still living in the house, and Katherine had become a teacher at the Fourth Ward School. (Photo Galena Historic Sites Office.)

PAUL HOUSE: 411 BOUTHILLIER STREET. Built of stone in 1838–1839, the Paul House looks much today as it did when John Paul constructed it. John and his new bride, Inez, were married in the house by Father Mazzachelli in 1839. John was a stone mason and builder who did some of the finest stone work in Galena. Their daughter, Mary Ann Paul, lived here for more than 80 years. (Photo Galena Historic Sites Office.)

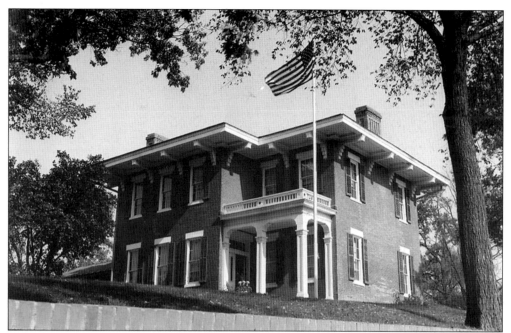

GRANT HOME: 500 BOUTHILLIER STREET. When the Civil War ended in 1865, General Grant returned to Galena amid cheers and a massive celebration. A group of Galena citizens purchased the home, built by A.J. Jackson in 1859, and presented it to Grant at a grand celebration in July of 1865. The authenticity of the interior of the Grant Home is remarkable, down to the smallest detail. It is open to the public for a small fee. (Photo Galena Historic Sites Office.)

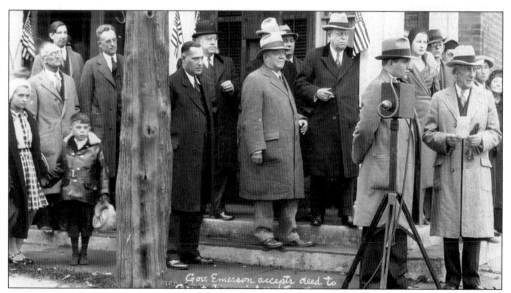

GRANT HOME: 500 BOUTHILLIER STREET. The Grants periodically spent time in Galena. In 1904, two years after Julia Grant died, her heirs presented the house to the City of Galena. Twenty-seven years later, the City gave the home to the State of Illinois. Pictured above is the ceremony, held on November 11, 1931, in which Governor Emerson accepted the deed. (Photo Mueller Collection.)

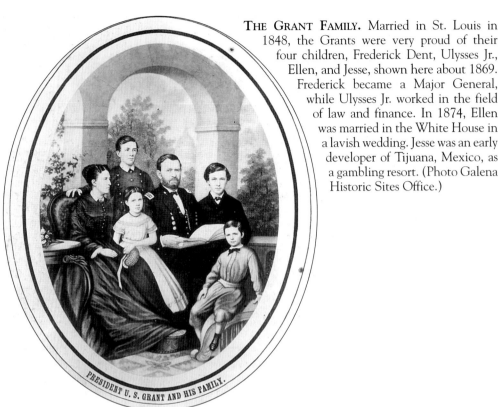

THE GRANT FAMILY. Married in St. Louis in 1848, the Grants were very proud of their four children, Frederick Dent, Ulysses Jr., Ellen, and Jesse, shown here about 1869. Frederick became a Major General, while Ulysses Jr. worked in the field of law and finance. In 1874, Ellen was married in the White House in a lavish wedding. Jesse was an early developer of Tijuana, Mexico, as a gambling resort. (Photo Galena Historic Sites Office.)

NOLAN AND GILL HOUSES: 508, 510, AND 512 BOUTHILLIER STREET. Taken shortly after a cyclone in February 1911, this photo shows the damage to the brick Nolan House (center), built by the Irish bricklayer in 1850. On the right stands the Gill House, built by James Gill, a laborer, in 1910. All three houses now belong to the State of Illinois. (Photo Mueller Collection.)

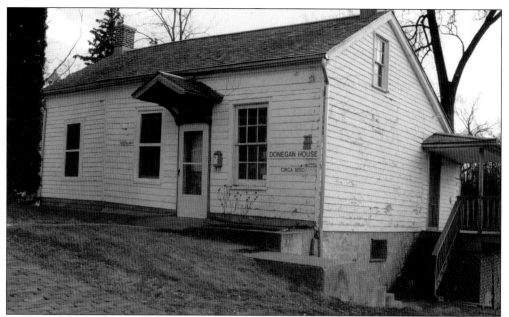

CROWSON HOUSE: 507 BOUTHILLIER STREET. Built in 1836–1837, this Greek Revival house was moved from Bench Street to the current location in 1983. It is significant as a documented example of early Galena and Upper Mississippi lead mining vernacular architecture and represents the culture and economic history of that period. Built by Jonathan Crowson, it was later acquired by Marcus Biesman, owner of the Lead Mine Cigar Factory. It is now owned by the State and has been stabilized for future use. (Photo Marsh Collection.)

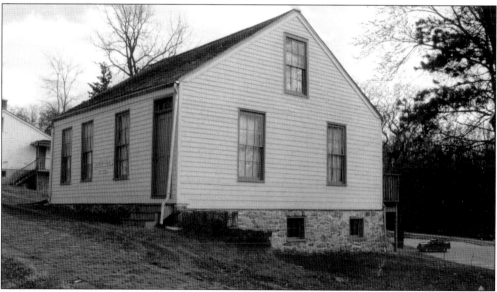

DONEGAN HOUSE: 511 BOUTHILLIER STREET. The Donegan family lived in this home for over fifty years, beginning with Michael, an Irish laborer, in 1854. By 1870, Christopher and his wife, Catherine (both of whom were born in Ireland) and their children, Mary, Owen, Henry, and Julia, lived in the house. In both 1900 and 1914, Miss Mary Donegan is listed as living in the house alone. It now belongs to the State of Illinois. (Photo Marsh Collection.)

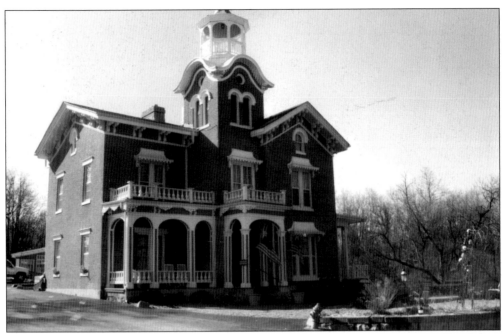

STILLMAN MANSION (BERNADINE'S STILLMAN INN): 513 BOUTHILLIER STREET. The Nelson Stillmans built their richly-detailed Italianate mansion in 1858. Nelson made his fortune as a dry goods and sugar merchant. The house became the Sunny Hill Nursing Home, and later, the Stevens Manor Restaurant. In 1975, the Jensens converted it to a bed-and-breakfast. They restored the widow's walk and many of the original features. The present owners have rehabilitated the carriage barn into an inviting supper club. (Photo Marsh Collection.)

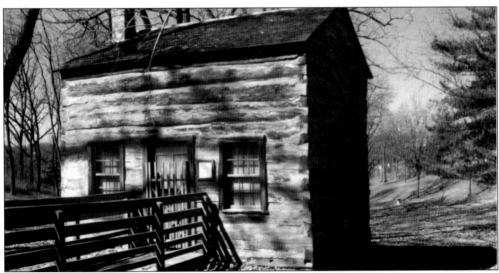

LONG CABIN: PARKING LOT ON ROUTE 20. John and Mary Long built this log cabin in Elizabeth Township in 1851, raising four children there. During the 20th century Henry and Rossina Binns lived in the cabin for 49 years. They had six children—can you imagine a family of eight living in this small cabin? It had one room below with a loft above and was heated by one stove. Mrs. Binns lived in it until 1970. In 1976 it was moved to this site. (Photo Marsh Collection.)

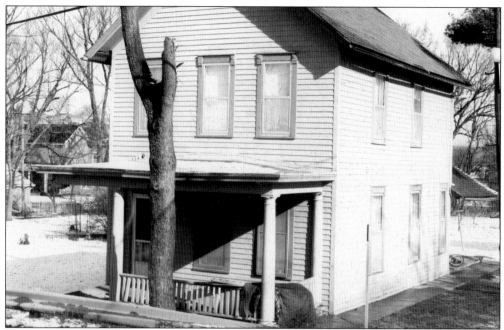

CALLAHAN AND KYLE-BRODBRECT HOUSES: 300 BLOCK DECATUR STREET (ROUTE 20).
Michael Callahan came from Ireland in 1848 and settled in Rodden. He and his wife, Jane, had seven daughters and two sons. Sadly, five of the daughters died in their twenties from consumption. In 1891, Michael moved to this house with three surviving children. The Brodbrecht House to the west, was built in 1838 by William Kyle. It has been stabilized for future use by the State of Illinois, its present owner. (Photo Galena Historic Sites Office.)

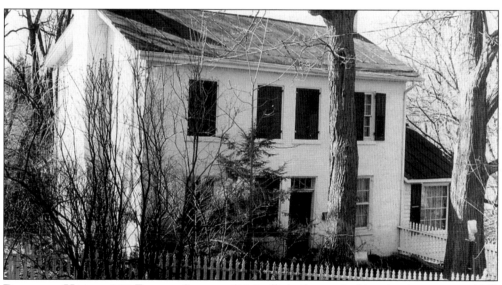

DELIHANT HOUSE: 901 FOURTH STREET. Originally built as a double miner's cottage in 1845 by James McGowan, this house appears to have been constructed as rental property for the use of miners working in Muddy Hollow. In 1861, it was purchased by George Kuntz, who made it into a single family home. Katherine Delihant, who bought it in 1933, opened the house for the annual home tour for 13 years. (Photo Galena Historic Sites Office.)

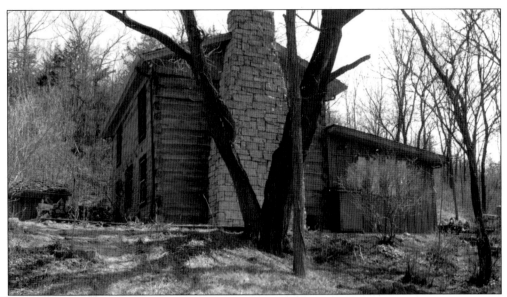

THE HOMESTEAD: 1022 FOURTH STREET. Charlotte Kennedy fell in love with this 1860s two-story homestead cabin when it was located in Iowa. She purchased the logs and brought them to this picturesque lot in 1983. With the help of local workmen and contractor Terry Cole, the cabin was reassembled. The house, which conveys a sense of early pioneer history, retains its charm while still allowing for modern living. (Photo Marsh Collection.)

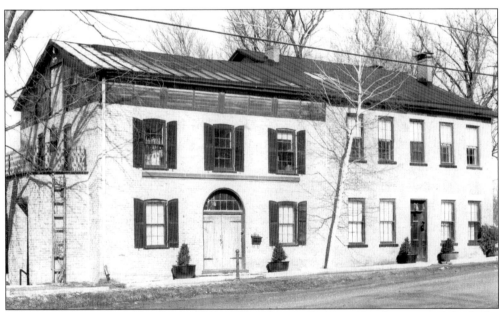

HOUY BREWERY: 1025 FOURTH STREET. Restored in the 1960s by designer Jo Mead, the former Houy Brewery had been abandoned and neglected. The north half was a tavern built in 1836, while the south half was the brewery (1840). The heavy wooden doors on the left were used by horses pulling loaded wagons. Stripped of its white paint, added at a later time, the building has been authentically restored. Draining the water out of one of the four underground caverns, Jo made it into a baronial dining hall. (Photo Galena Historic Sites Office.)

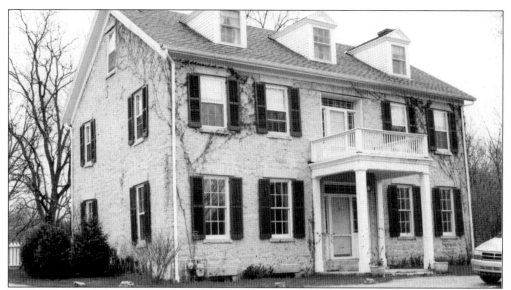

DeZoya House (DeZoya Bed-and-Breakfast Inn): 1023 Third Street. An excellent example of an early Federal style mansion, the stone DeZoya House was built in 1838 by John Paul DeZoya, a Swiss emigrant who arrived in Galena in 1833. He served on Galena's first board of trustees in 1839 and held the office of county treasurer from 1851–1853. The front of the beautifully restored house faces the Galena River. (Photo Galena Historic Sites Office.)

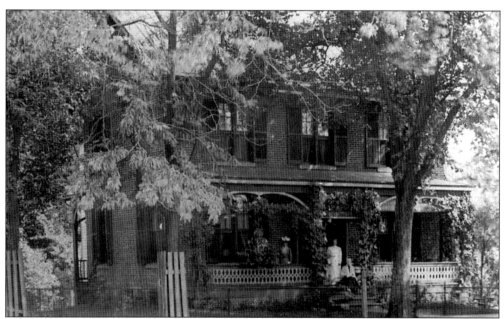

Snyder House (Snoop Sister Bed-and-Breakfast Inn): 1000 Third Street. William Snyder, an officer in the Galena Insurance Company, built this substantial Greek Revival home in 1856. He was an amateur archaeologist with an interest in Indian mounds. The name "Snoop Sisters" was chosen by the previous owners, who asked their children to pick a name for their new business. The children replied, "'Snoop Sisters,' because you two are the snoopiest sisters we know." (Photo Mueller Collection.)

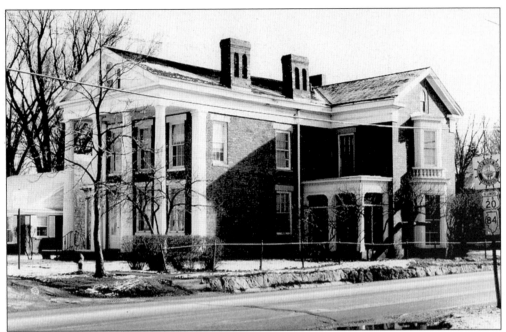

WASHBURNE HOUSE: 908 THIRD STREET. It was because of Elihu Washburne that U.S. Grant and several of the other Galena generals gained prominence during and after the Civil War. The Washburnes built this elegant home in 1844. A close friend of Lincoln and Grant, Washburne bolstered Grant's military and political careers. While in this home's library, Grant, through the use of a special telegraph connection, received the news that he had been elected president. (Photo Courtesy Mueller Collection.)

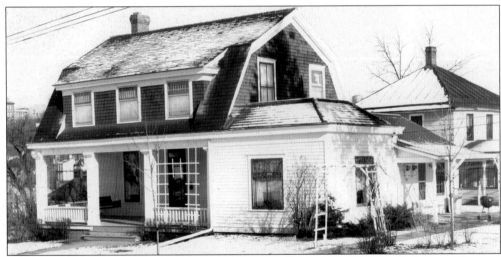

NACK HOUSE: 208 LaFAYETTE STREET. A charming version of the Dutch Colonial Revival style, the Nack House was built in two stages, with the earlier section (on the right) consisting of one story with two rooms. About 1906, W.P. Cleveland, a mine superintendent, added the living room and bedrooms. When the Nacks moved in during 1966 and began restoring the house, they uncovered an elaborate parquet floor and decorative ceiling beams. (Photo Galena Historic Sites Office.)

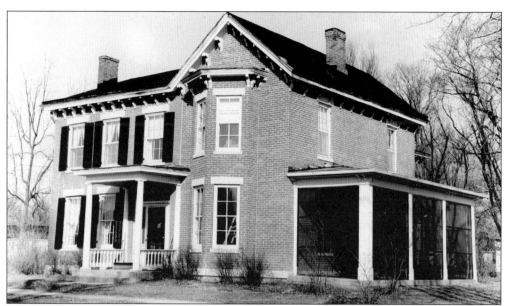

ALDRICH HOUSE (ALDRICH GUEST HOUSE): 900 THIRD STREET. Cyrus Aldrich built a small two-story brick house in 1846, while representing Galena in the state legislature. In 1853 he sold it to J. Russell and Elizabeth Jones and moved to Minnesota. The Joneses added a two-story addition to the front (left half). Russell was rapidly making his fortune as a partner in a steamboat company. In 1860, he represented Galena in the State Assembly. (Photo Mueller Collection.)

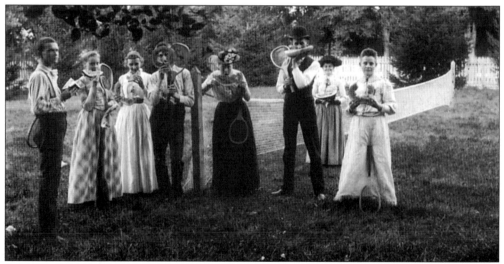

ALDRICH HOUSE (ALDRICH GUEST HOUSE): 900 THIRD STREET. In 1858, the Robert McClellans bought the house. They also added a two-story addition to the front. On the right half of the front facade you can see the seam to the right of the front portico. McClellan, a lawyer and bank president, was elected to the state legislature in 1861. The Galena Country Club occupied the property at the turn of the century when the photo above was taken. (Photo Mueller Collection.)

DOWLING-GREENE HOUSE: 1002 PARK AVENUE. Bernard Dowling, a member of one of Galena's pioneer families, built the Greek Revival house shown above in 1846. In 1873, Darius Hunkins, who lived next door, bought it as a wedding present for his daughter Miriam and her new husband, Edward Greene. An 1877 addition on the back connected the two houses through a doorway, now walled over. (Photo Galena Historic Sites Office.)

HUNKINS MANSION (ANNIE WIGGINS): 1004 PARK AVENUE. Colonel Darius Hunkins arrived in Galena in 1838 to superintend the Illinois Central Railroad. In 1842, he engaged in mining and smelting, and in 1847, built the Spring and Meeker Street bridges. He used part of his fortune to build this elegant Greek Revival mansion in 1846. The present owners named the inn "Annie Wiggins," in honor of the Victorian lady owner Wendy Heiken plays so well. (Photo Mueller Collection.)

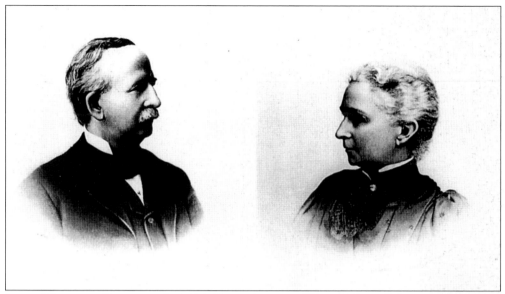

JONES MANSION (BELVEDERE): 1008 PARK AVENUE. When J. Russell Jones and Elizabeth Scott met in 1847, she had come from Arkansas to visit her older sister, Eliza Campbell. Elizabeth and Russell fell madly in love and Russell proposed. Eliza forbade them to ever see each other again because Russell was not "socially acceptable." Elizabeth wrote, "I would rather die than live without the one I love." She didn't die. Instead, they were married in 1848. They built their beautiful mansion nine years later. (Photo Galena Historical Museum.)

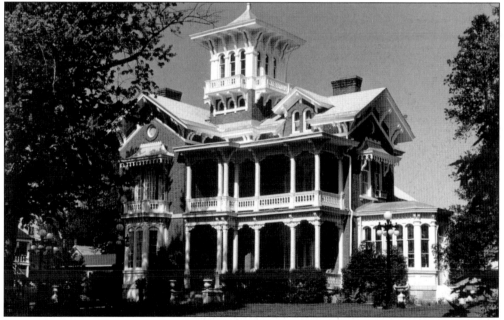

JONES MANSION (BELVEDERE): 1008 PARK AVENUE. When J. Russell Jones entered Galena on an old white horse in 1840, he didn't know a soul, didn't have a job, and had only a few dollars in his pocket. Working his way up, Russell became manager and part owner of a steamship company. In 1857, he and Elizabeth built this house, called "the grandest mansion in all of Northern Illinois." It cost $30,000 to build. (Photo Courtesy Galena History Museum.)

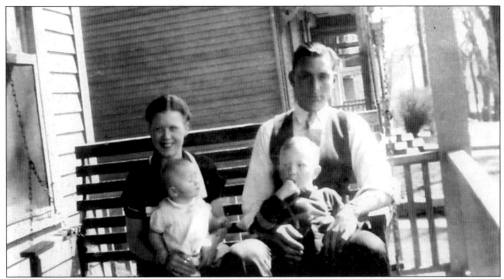

CAILLE-GABER HOUSE: 910 PARK AVENUE. Barbara and Merle Gaber, with Barbarann and Merle Jr., enjoy the porch swing at 910 in 1939. When the Gabers were married at St. Michael's Church in December of 1934, Mr. and Mrs. John Crawford gifted them with this house as a wedding present. Barbara had worked for the Crawfords, who lived next door at 908. George Caille, a confectioner, built this house in 1882. (Photo Barbarann Gaber Price Collection.)

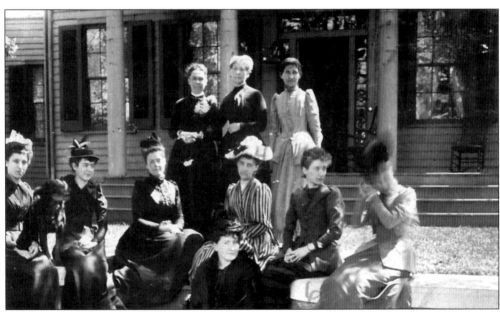

BATES-COGLEY SOULARD HOUSE: 908 PARK AVENUE. Several of Galena's most fashionable ladies pose on the front wall of the Soulard's home about 1890. Concealed by the walls of this well-kept Greek Revival home are the logs of a cabin built by Nehemiah Bates before 1821. It was sold to D.H. Cogley in 1846. The funds from that sale were used to send the two Bates daughters to St. Rose Academy in St. Louis. The Cogleys covered the original cabin with clapboard siding. (Photo Mueller Collection.)

BATES-COGLEY SOULARD HOUSE: 908 PARK AVENUE. The Soulards bought the house from the Cogleys in 1855. Moving to Galena in 1827, they became prominent in horticultural circles. After they purchased this house they continued to improve it, creating the well-kept Greek Revival home you see today. Here, Harriet Crawford, the granddaughter of James Soulard, talks with Barbara McLimans (Gaber) in front of Harriet's home. The Gabers lived here from 1943–1947, after the Crawfords moved East. (Photo Barbarann Gaber Price Collection.)

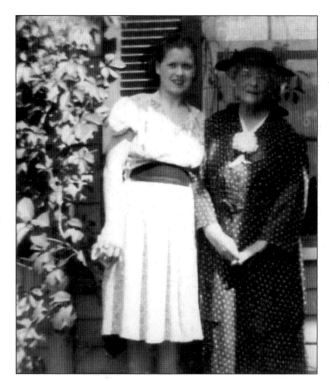

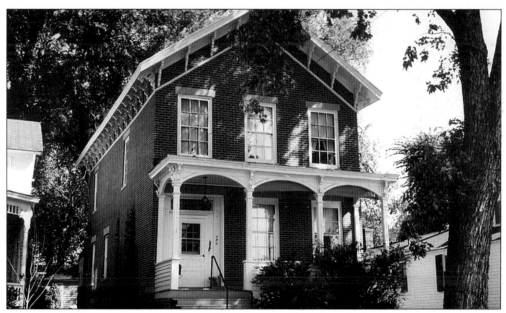

BEEBE HOUSE: 906 PARK AVENUE. When Captain Edward Beebe built this home in 1869, it was in the form of a one-and-a-half story Greek Revival house. In 1855, Captain Beebe helped organize the Galena Gas Company. In 1892, Michael Birmingham, a grocer, rebuilt the house in the present Classic Revival with Victorian porch and Italianate brackets. The north third of the house was removed in 1894 to make a full lot suitable for the building of the Coatsworth house next door. (Photo Galena Historic Sites Office.)

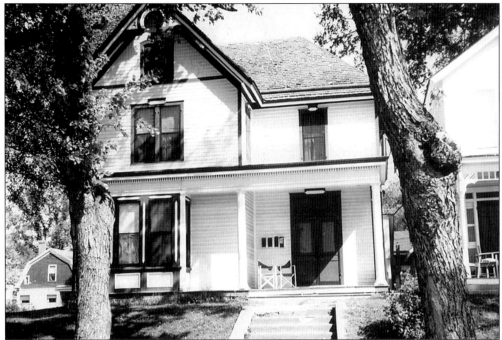

COATSWORTH HOUSE: 904 PARK AVENUE. Michael Birmingham, who lived next door at 906 Park Avenue, sold the land for this Queen Anne cottage to Joseph Coatsworth in 1894 for $650. Joseph and his bride, Clara (Turner) were married in October of 1894 and returned from their honeymoon to live in their brand-new home. The owner of the largest jewelry store in Galena, he was the third generation of the Coatsworth family to own that business. (Photo Galena Historic Sites Office.)

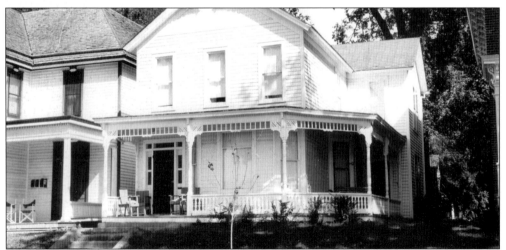

McDERMOTT HOUSE: 902 PARK AVENUE. An agent for the Illinois Central Railroad, T.L. McDermott and his wife, Catherine, built their Queen Anne home in 1885. They had nine children, all still at home in 1899. Grown children included Bennett, a railway agent, Agnes and Joseph, post office clerks, and William, a telegrapher. In 1900, Andrew Heron, the business manager of the *Galena Gazette*, and his wife, Anna, bought the house. (Photo Galena Historic Sites Office.)

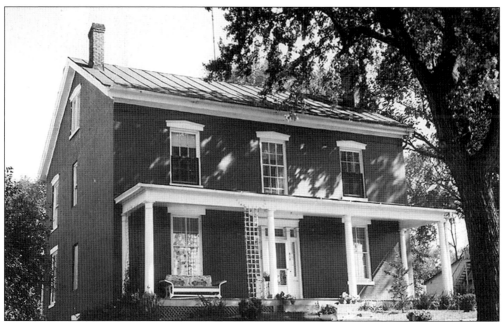

WOODWARD HOUSE: 810 PARK AVENUE. George Woodward, the builder of this Greek Revival house in 1852, was a Unitarian minister. His large household included four children and two servants. He helped organize the first Galena Gas Light Company in 1855 and was clerk and collector for the City in 1853. By 1900, Thomas Foster, president of the Merchants National Bank and partner in the Galena Woolen Mills, lived here. (Photo Courtesy Galena Historic Sites Office.)

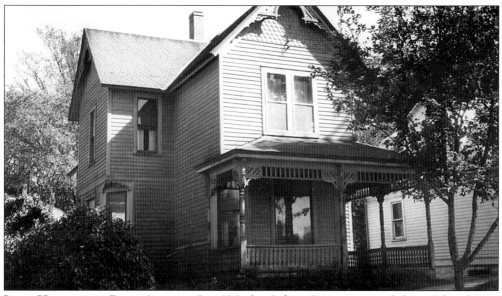

LACY HOUSE: 804 PARK AVENUE. In 1896, the *Galena Gazette* reported that, "Edward Lacy has built an attractive residence." The Queen Anne house features a wrap-around porch, cut-out railing, ball and spindle porch trim, decorative ornamentation, and fish scale shingles in the gable fronts. Edward was a telegraph operator. (Photo Galena Historic Sites Office.)

ABBOTT HOUSE: 912-914 PARK. This 1930s photo features one of Galena's earliest double houses, the Abbott House, which was valued at $ 3,000 after it was built in 1844. It represents an early type of construction on the Upper Mississippi. A professional preservationist pointed out that it should be saved, even though it was in the way of the new bridge. Accordingly, the bridge was moved ten teet to the south, in order to preserve the building. (Photo Mueller Collection.)

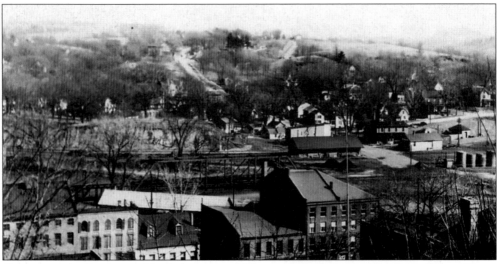

OVERVIEW. A clear view of Park Avenue can be seen from the west side of the Galena River. The train tracks and the Illinois Central Railroad Depot, as well as the side of the smaller depot across the street, are in this turn-of-the-century photo. The light path up the hill is Bouthillier Street. The large house on the right at the top of the hill is the Stillman mansion and the house on the left is the Grant Home. (Photo Mueller Collection)

Three

THE VIEW FROM THE LEVEES

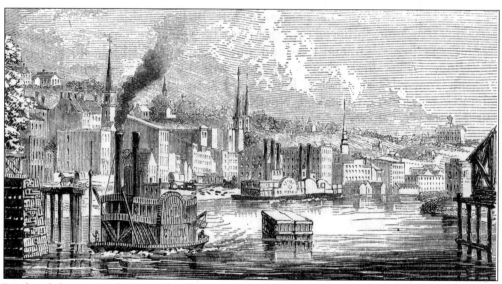

Lead and the river—those are the dynamic natural resources that made Galena. Today, mining has ceased, and although the river still meanders through the center of town, it is no longer a necessary economic force. Galena was once the largest port between St. Paul and St Louis. The boats made their way up from the Mississippi, three miles away, to Galena. Here, they picked up lead and delivered other commodities, sailing back to the Mississippi again. During the spring, summer, and fall of the 1840s, 50s, and 60s, as many as 12 steamboats a day could be seen lined up against the western shore of the basin. Although the lead and steamboats are now gone, Galena's historic buildings remain, a vivid reminder of the city's rich heritage. Galena is sometimes called "the town that time forgot." However, Daryl Watson tells us that for 150 years, tourists have been attracted by Galena's architecture and scenery. A good example of this would be the arrival of the steamboat *Helen Blair* on April 27, 1913, bringing about 40 tourists to see Galena's historic sites. Today more than 1.3 million visitors come each year to enjoy the city's beauty. (Photo Galena Museum.)

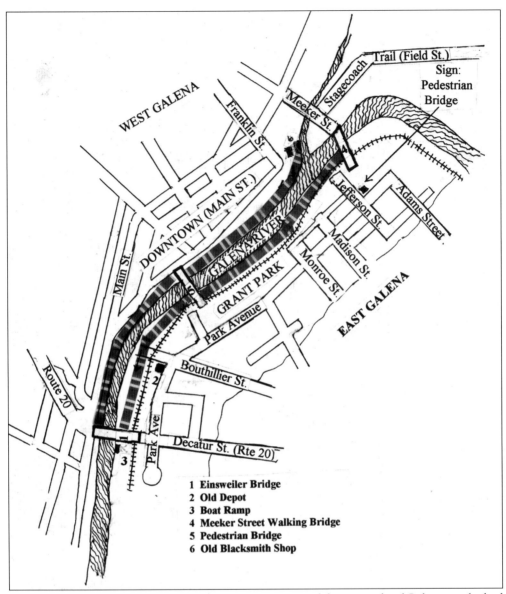

MAP OF THE LEVEE WALK. An inspiring panoramic view of the west side of Galena can be had from either the east or west levees bordering the Galena River. You may start your walk from either the south (Old Depot) end or the north (Meeker Street Walking Bridge) on the east bank. On the west side, you can start at the pedestrian bridge, take the new walk along the top of the bank, and exit at the path near the Old Blacksmith Shop. There is a handicapped ramp on the north end, near the Old Blacksmith Shop. You can look at the photos in this book and try to imagine Galena as it was during the 19th and 20th centuries. Take time to enjoy the birds and wildlife that live along the river. (Please stay off of the railroad tracks.)

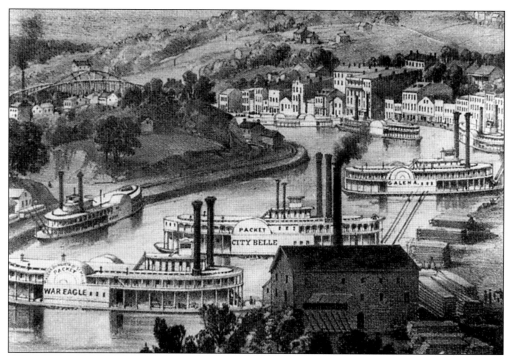

THE WAR EAGLE. The first *War Eagle*, owned and piloted by the famous Captain Daniel Smith Harris, was perhaps the swiftest boat to navigate the Upper Mississippi before 1850. The first *War Eagle* ran from St. Louis to Galena in 47 hours and 52 minutes, a record that stood for many years. The second *War Eagle*, which brought thousands of immigrants to the region for 16 years, was built in 1854. (Photo Galena Historical Museum.)

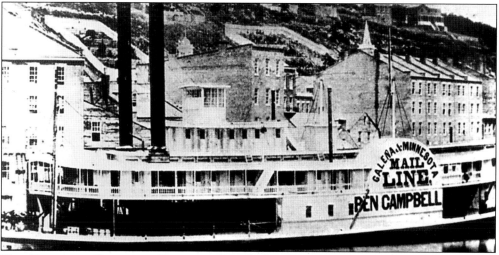

THE *BENJAMIN CAMPBELL*. Benjamin Campbell, who arrived in Galena in 1835, was a successful wholesale grocer for several years before going into the steamboat business. The Galena and Minnesota Packet Company (1850) contributed significantly to the development of much of Minnesota, Wisconsin, and Iowa. In 1861, the firm closed, and in 1869, Ben moved to Chicago to become U.S. Marshal for Northwestern Illinois. Note the grand terraced gardens on the hill above Main Street. (Photo Galena Historical Museum.)

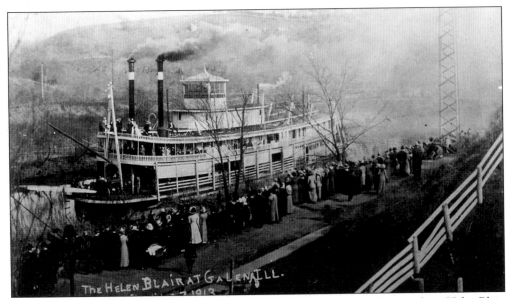

THE STEAMBOAT *HELEN BLAIR*. April 27, 1913 marked the arrival of the steamboat *Helen Blair*. She brought over 40 excursionists from Rock Island, Davenport, and Dubuque to Galena. They were given automobile tours to see the Grant Home and other historical sites. Many Galenians came to see the excitement. Afterwards, the boat had to back down the Galena River until it reached the Mississippi. Tradition says that this was the last steamboat to visit Galena. (Photo Galena Historical Museum.)

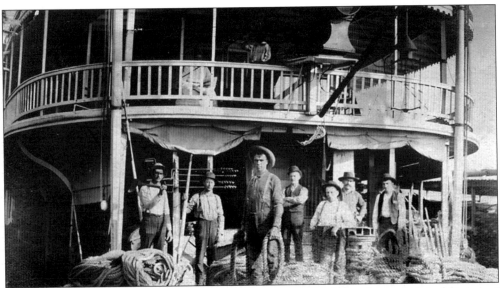

WORKING ON THE STEAMBOATS. Most of the boats that ascended or descended the Mississippi stopped in Galena. The wild stampede to the Fever River lead mines began in 1827. Galena became the metropolis of the lead region. Working aboard the steamboats was not only hard labor, but was also dangerous due to fires and explosions. Besides the thousands of passengers, boatloads of horses, mules, cattle, sheep, and hogs were transported through Galena. (Photo Galena Historical Museum.)

DREDGING THE RIVER. A government dredge boat scoops silt from the Galena River. By 1859, siltation from mining and agricultural practices caused river traffic to be temporarily suspended. The Dubuque City Council, Galena's rival, was happy to see the plight of its neighbor, and claimed it was ready to pass a resolution recommending that the river "be plowed up and potatoes planted." Then someone observed that the ground was too dry. (Photo Galena Historical Museum.)

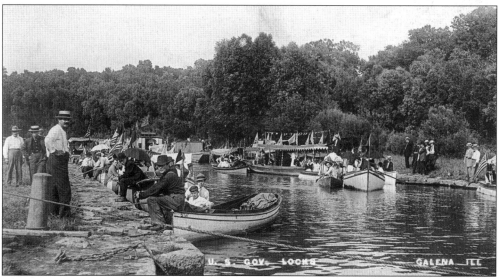

A SUNNY DAY ON THE RIVER. Not only did the river provide a living for many residents, but it was also used as a recreation spot in good weather. Many Galenians owned launches, small boats with solid or awning type tops and open sides. Some were decorated with fringes and flags, adding to the gay atmosphere. Motor boats and canoes still take advantage of the river scenery and fresh air. (Photo Galena Historical Museum.)

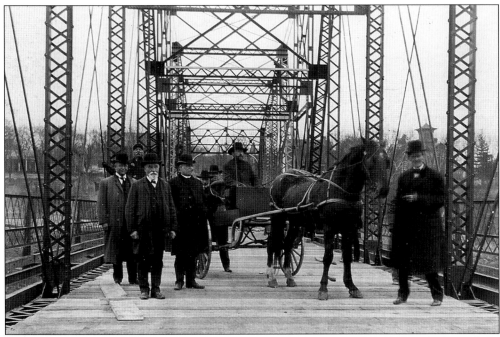

SPRING STREET BRIDGE DEDICATION. When the Spring Street Bridge was finished, residents had a rousing discussion about who should have the significant honor of being the first local dignitary to drive across the bridge. While they were deciding, M. Leslie Johnson, a prominent Galena scientist and inventor, hitched up his old horse, "Stanley," and became the first to cross the bridge. The bridge was later replaced by the present Einsweiler Bridge. (Photo Galena Historical Museum.)

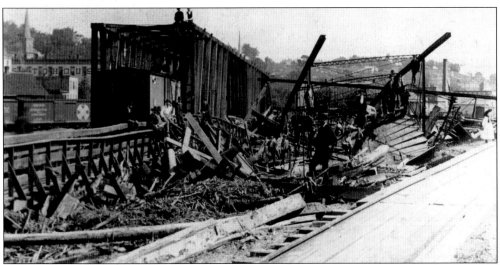

DISASTER. The *Galena Gazette* reported, "The heavy rains of yesterday (June 24, 1892) rendered the already swollen river a monster which filled the populace with horror and consternation." About 3,000 people watched from Grant Park as mountains of debris traveled down the river. This photo shows the remains of the Green Street Bridge washed up against the Burlington Railroad Bridge (Photo Galena Historical Museum.)

DREDGING THE RIVER. A government dredge boat scoops silt from the Galena River. By 1859, siltation from mining and agricultural practices caused river traffic to be temporarily suspended. The Dubuque City Council, Galena's rival, was happy to see the plight of its neighbor, and claimed it was ready to pass a resolution recommending that the river "be plowed up and potatoes planted." Then someone observed that the ground was too dry. (Photo Galena Historical Museum.)

A SUNNY DAY ON THE RIVER. Not only did the river provide a living for many residents, but it was also used as a recreation spot in good weather. Many Galenians owned launches, small boats with solid or awning type tops and open sides. Some were decorated with fringes and flags, adding to the gay atmosphere. Motor boats and canoes still take advantage of the river scenery and fresh air. (Photo Galena Historical Museum.)

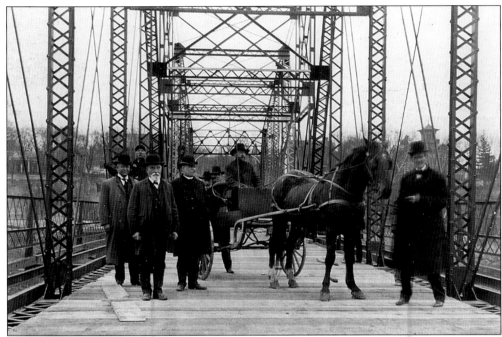

SPRING STREET BRIDGE DEDICATION. When the Spring Street Bridge was finished, residents had a rousing discussion about who should have the significant honor of being the first local dignitary to drive across the bridge. While they were deciding, M. Leslie Johnson, a prominent Galena scientist and inventor, hitched up his old horse, "Stanley," and became the first to cross the bridge. The bridge was later replaced by the present Einsweiler Bridge. (Photo Galena Historical Museum.)

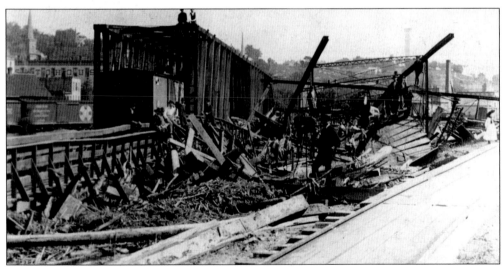

DISASTER. The *Galena Gazette* reported, "The heavy rains of yesterday (June 24, 1892) rendered the already swollen river a monster which filled the populace with horror and consternation." About 3,000 people watched from Grant Park as mountains of debris traveled down the river. This photo shows the remains of the Green Street Bridge washed up against the Burlington Railroad Bridge (Photo Galena Historical Museum.)

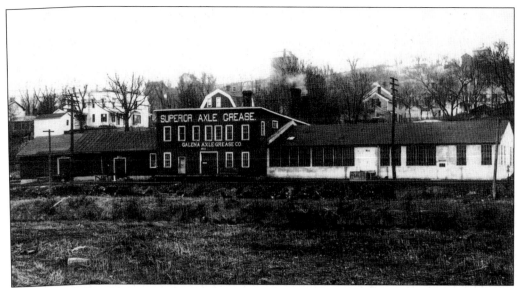

GALENA MANUFACTURING COMPANY: 100 MONROE. Facing the river on the east side, the Galena Manufacturing Company started life as the Galena Axle Grease Company in 1887. The first owners were Tom Roberts, Sam Fraser, and George Avery. Fraser was called "the boss grease maker of the world." By 1915 the company was receiving more orders for wire handles than for axle grease and changed its name to Galena Manufacturing Company. The old oil vats, no longer in use, are still located in the historic building. (Photo Alfred Mueller .)

THE OLD BLACKSMITH SHOP (CORNER OF WATER AND COMMERCE STREETS). Galena's newest museum, the Richardson Blacksmith Shop, has been restored as authentically as possible. Willard Richardson bought the 1897 shop in 1923. Blacksmiths played an important role in the town's economy until the 1940s and 1950s, gradually shifting their clientele from the general public to farmers. There is a book and gift store behind the shop. Stop in and get a real taste of Galena's rich agricultural past. (Photo Galena Historical Museum.)

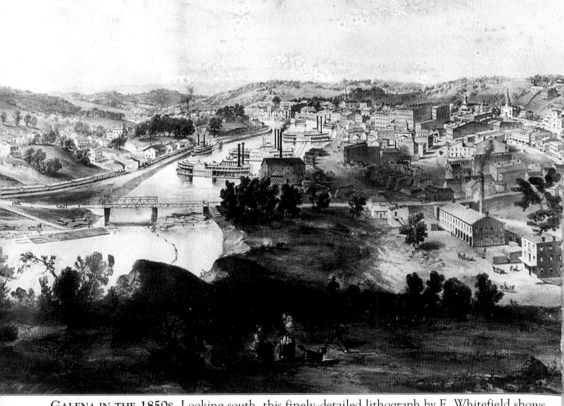

GALENA IN THE 1850S. Looking south, this finely-detailed lithograph by E. Whitefield shows us much about Galena in 1856. The Meeker Street wagon bridge crosses on the left, and the Westwick Foundry is in the right foreground. Main and Bench Streets curve gently to the north to the right of center. Both steamboats and new Illinois Central Railroad tracks are visible in this drawing, with two trains progressing along the double tracks on the east (left) side. In 1838, Galenians came close to becoming Washingtonians. There were few shops on the east side of the river, and residents had to take a ferry to the west side to businesses and activities on Main Street. Residents presented a petition to Jo Daviess County officials, requesting that the east side be designated as the separate town of Washington. The plan fell through when it was discovered that there was already a Washington, Illinois. Eventually the idea died, aided by the first two bridges at Spring and Franklin Streets. During the last 160 years, more than 25 bridges have spanned the river at different times. (Photo Galena Historical Museum.)

Four

Main and Bench
Streets
Galena's Heart

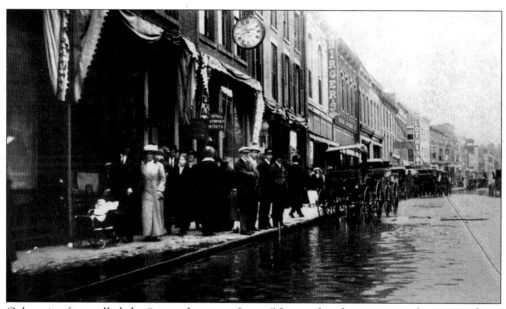

Galena is often called the "town that time forgot." Long after downtowns in large cities have been developed with rows of high-rise buildings and those in many small towns have been irretrievably altered or abandoned, Galena's commercial center doesn't look much different than it did 150 years ago. The cars, clothing and baby carriages may have changed, but the streetscape still surrounds us with the atmosphere of the 19th century. In 1976, historical plaques were placed on many of the buildings on Galena's streets. It is worthwhile to stop and read them. This book does not go into detail about the downtown buildings because its focus is on the neighborhoods and homes of Galena's families. However, it is important to note that Main, Bench, Commerce, and Water streets played a significant role in the lives of early residents. Many Galenians went downtown to work and to shop every day. For further information about books and tours, contact the Galena historical Museum at 211 South Bench Street, (815) 777-9129. Their bookshop features books about Galena, the Civil War, General Grant, and other materials about the Victorian period. Walking tours can be arranged through the museum. (Photo Galena Historical Museum.)

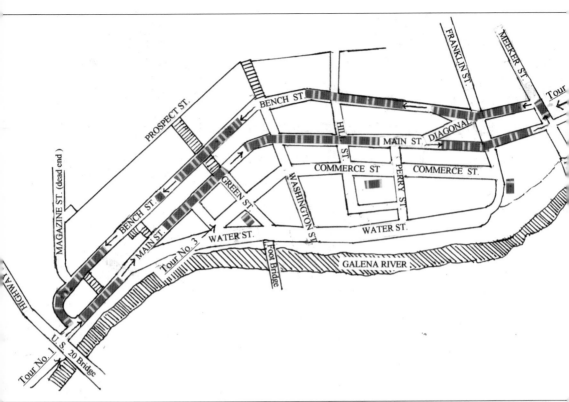

MAP OF MAIN STREET AND BENCH STREET.

Main Street (Tour One): Going with the traffic flow, Tour One starts at the flood gates and goes north on Main Street.

Bench Street (Tour Two): To reach Bench Street, turn left at Meeker Street from Main Street and left again at Bench Street. You will be going in the right direction (south) to take Tour Two. Traffic on Bench Street runs South only, from Franklin Street to the corner of Bench Street and Riverside Drive.

Main Street (Tour Three): To go back into downtown in order to take Tour Three, turn left at Main Street to Commerce Street. Three of Galena's most significant historical buildings are on Commerce Street, to the east of Main Street. The Post Office, Market House, and Blacksmith Shop all face Commerce Street. To visit them, turn right on Green Street.

THE FLOODGATES: 500 SOUTH MAIN STREET AT RIVERSIDE DRIVE. Built from 1948–1951 by the U.S. Corps of Engineers, the levees and flood gates protect both sides of the river. When the water rises where Riverside drive meets Main Street, the large green gates are closed and sand bags placed along the bottom. This usually happens at least once a year and often lasts for as long as two weeks. The west levee is located over the area where the steamboats once docked. (Photo U.S. Army Corps of Engineers.)

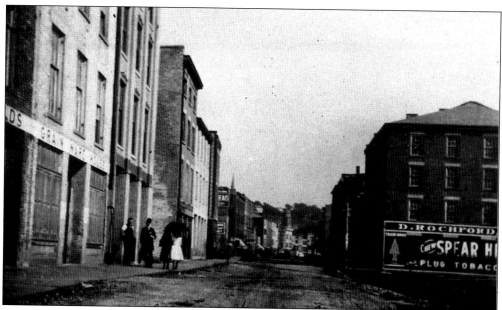

MAIN STREET: 400 BLOCK SOUTH. The 1845 Peck-Hempstead Building on the right was restored by the owners of the Galena River Wine and Cheese Company. The buildings on the left were grain warehouses. Wagons, and later trucks, loaded the grain into the top floor on Bench Street. It was processed and the finished product loaded onto trucks at the Main Street entrances. The stone walls at the back of the parking lot are what is left of those buildings. This was the beginning, and, fortunately, the end of Urban Renewal in Galena. (Photo Mueller Collection.)

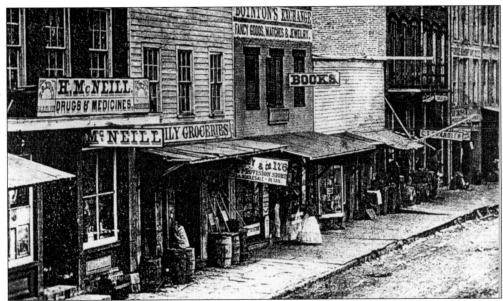

MAIN STREET. Many, but not all, of the earliest commercial buildings along Main Street were constructed of wood. The danger of fire was constant, and there were several fires during the early days. The disastrous fire of 1856 destroyed 33 buildings and affected five blocks of Downtown Galena. New buildings of sturdy brick replaced those destroyed by the fire. Among the earlier business establishments were McNeill's Drug Store and Boynton's Exchange (books, watches, fancy goods, and jewelry). (Photo Mueller Collection.)

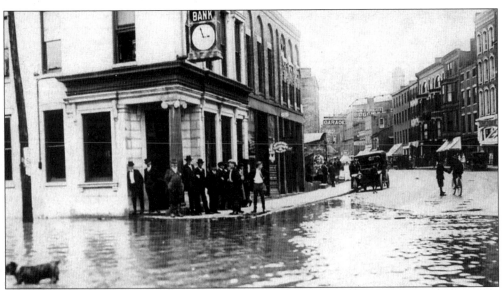

MAIN STREET: 200 BLOCK SOUTH. The First National Bank is shown on the left during one of the many floods that occupied Main, Commerce and Water Streets. Downtown Galena had several major floods during its first 125 years of existence. Many residents say that the flood in 1937, which engulfed the entire downtown, was the worst. Approximately five feet of water covered most areas along Main and Commerce Streets. The floods inspired people to bring out their cameras as if to say, "Can you believe this?" (Photo Galena Historical Society.)

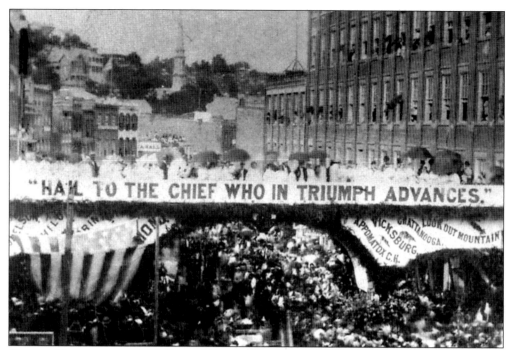

GRANT CELEBRATION: 200 BLOCK SOUTH MAIN STREET. On August 19, 1865, General Grant returned to Galena. A Chicago newspaper reported, "Galena is in its glory today. . . . He arrived here after a triumphant journey from Chicago during which he was given ovations at every station and hamlet along the route. Minute guns were fired as the train passed. On arrival [in Galena] he was met at the station by fully 10,000 persons. He and his party went to the DeSoto House where 36 beautiful young ladies, dressed in white, formally greeted him." (Photo Galena Historical Museum.)

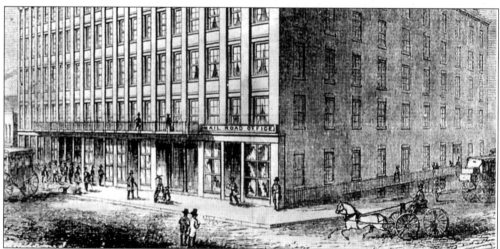

DESOTO HOUSE (HOTEL): 230 SOUTH MAIN STREET. The centerpiece of Main Street, the DeSoto House was built in 1853 by the Galena Hotel Company. Both Lincoln (July 1856) and Stephen Douglas (July 1858) spoke from its balcony. Originally built with 225 rooms, the hotel featured a dining room that could seat 300 people. One hundred years later, the hotel was restored with a combination of federal, state, and private funds. (Photo Mueller Collection.)

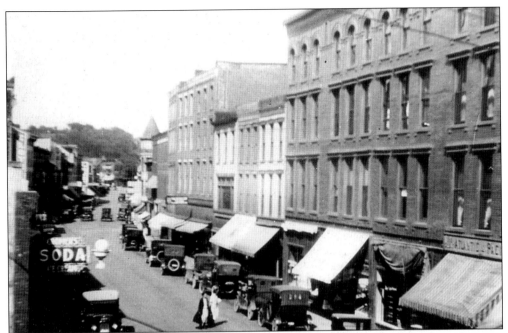

MAIN STREET: 100 BLOCK. By the early 1920s, Main Street was lined with cars, a dramatic change in American travel habits. However, Galena's downtown hadn't changed much. The building on the near right is the Coatsworth Building (120–126). The third building (114) is the Old Mercantile building, later the YMCA. The gymnasium still survives on the third floor. The tile entrance to 110–112 still bears the name of the Millhouse Brothers, who owned a successful hardware store there. (Photo Galena Historical Museum.)

THE OLD STOCKADE: PERRY STREET. One of Galena's most significant historic buildings, the Old Stockade was built of upright virgin limbers in the French style. The building served as a warehouse for Galena's early Native American fur traders in the 1820s. During the Black Hawk War of 1832, it was a refuge for women and children. Home to Sophia gear Farrar (1831–1883), Margaret Gardner (1884–1914), and Maybelle Rouse (1941–1965), the building was a museum from 1965 to 1995. It is now the etching studio of Galena artist Carl Johnson. (Photo Galena Historic Sites Office.)

DOWLING HOUSE: 216 DIAGONAL STREET. A very old surviving home and business, the 1826–1827 John Dowling House, built of limestone, was originally a trading post on the first floor and a residence on the second. Abandoned and in extremely poor condition, the building was restored in the 1960s by William McCauley as his residence. In the 1970s, Ralph Benson opened the building for tours. It offers a fascinating look at early Galena. (Photo Galena Historic Sites office.)

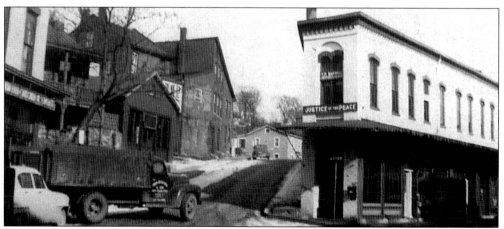

MAIN AND DIAGONAL STREETS: 224 NORTH MAIN STREET. Otis Horton built the triangular building in the right half of this photo, sometimes called the Flatiron Building, in 1877, after the original building on the site burned. Diagonal Street cuts through at the left. The Dowling Building, built in 1837, is on the extreme left, and the Vincent Monument Co. is beyond the truck. The John Dowling House is in between and has been authentically restored as a museum. (Photo Mueller Collection.)

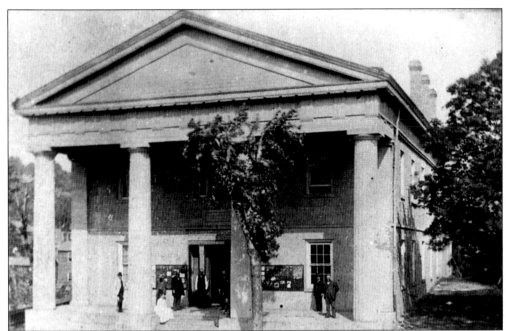

JO DAVIESS COUNTY COURTHOUSE: 330 NORTH BENCH STREET. Begun in March of 1839, the Jo Daviess County Courthouse originally sported a classic Greek Revival portico. It was partially funded by the sale of Galena town lots by the U.S. Government. After the masonry work was completed, further construction was delayed for four years, due to lack of funds. The building was completed in 1844. One of the superintendents was Father Samuel Mazzachelli, a Catholic priest who showed a genius for architecture. (Photo Muller Collection.)

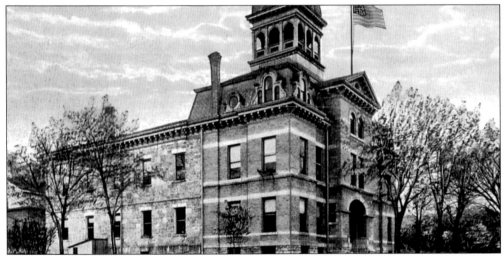

J.D. COURTHOUSE: 330 NORTH BENCH STREET. IN 1900, the *Galena Gazette* (July 10, 1900) envisioned the new courthouse façade as "quite imposing, a thing of beauty, and a vast improvement over the ancient and primitive structure. The old portico, which is about to fall down, will be removed and an addition three stories high. . . ." The new front façade was designed in the popular and imposing Second Empire style. In the 1970s, additions faced with native limestone were built in the back to house the jail. (Photo Spurr Collection.)

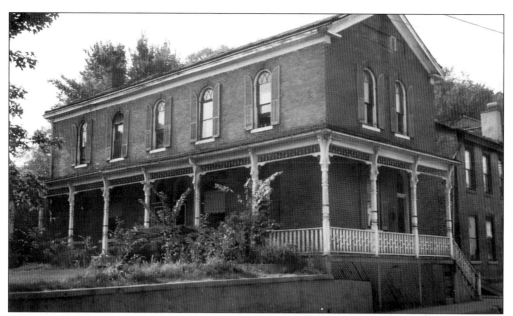

ST. ROSE ACADEMY: 228 NORTH BENCH STREET. Built in 1859 as a Catholic girls' school operated by the Dominican Sisters of Benton, Wisconsin, the graceful Italianate building was designed by Father Samuel Mazzachelli. Note the delicate arched segmental second floor windows and Victorian porch. From 1868–1875, the building was in use as Wartburg College, operated by Pastor Klindworth of the German Lutheran Church. Classes were taught in German. The Irish American Benevolent Society bought it in 1876 for $1700. (Galena Historic Sites Office.)

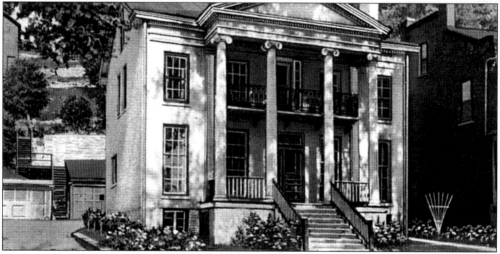

STRODE HOUSE: 120 NORTH BENCH STREET. Featuring two-story high classic Ionic columns, this fine mansion was home to several prominent Galenians. It was built in 1846 by James Strode who was a colonel in the 27th Illinois Regiment during the Black Hawk War. Arriving here in 1827 from Kentucky, he was a lawyer. Nicholas Dowling, elected to Galena's first city council in 1841, was the second owner. He helped found the Galena Insurance Company (1857) and the Galena and Southern Wisconsin Railroad (1873). The house is beautifully maintained by the present owner. (Photo Spurr Collection.)

FIRST PRESBYTERIAN CHURCH: 106 NORTH BENCH STREET. Built of native limestone in 1838, the First Presbyterian Church is the longest continuously occupied church in Galena. The imposing front façade and spire were added in 1855. The founding pastor was Rev. Aratus Kent who came West to preach at a place "so tough no one else would take it," as Galena's lead mining community was described. The beautiful stained glass windows were installed between 1890 and 1910. (Photo Spurr Collection.)

MILLHOUSE HOUSE: 102 NORTH BENCH STREET. In 1899 August and Maud Millhouse built this lovely Queen Anne home after tearing down an earlier house on the property. The *Galena Gazette* reported that "it was Mr. Millhouse's intention to replace the present building by one of modern style." A.J. "Jick" Millhouse owned a very successful hardware store in Downtown Galena with his brother, George. He was active in getting the first street lights installed and the first street paved in Galena. The rich house colors are typical of this style. (Photo Galena Historical Museum.)

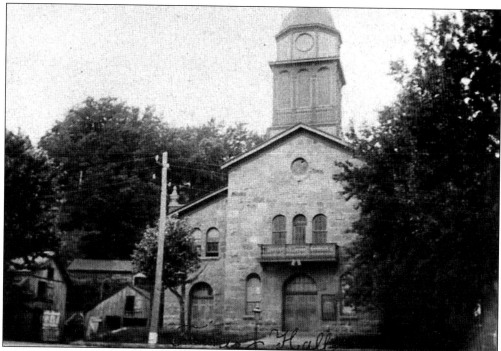

TURNER HALL: 105 SOUTH BENCH STREET. The Galena Sociale Turner Gemeinde, founded here in 1851, built this hall in 1874. The need for a public hall was considered the "greatest of all needs" in Galena at the time. Several gentlemen from Germany, including Christor Barner (sheriff), Matt Meller (owner, Fulton Brewery), and Rudolph Speier (owner, City Brewery) were on the building committee. Tom Thumb appeared here in 1877 and Teddy Roosevelt in 1900. The building was rebuilt after a major fire in 1926. It continues to be an important gathering place for Galena events. (Photo Galena Historical Museum.)

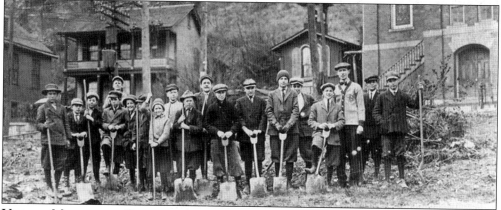

UNITED METHODIST CHURCH AND FIRE HOUSE NO. 1: 125 SOUTH BENCH STREET. Members of the Galena Civic Improvement League are shown ready to go to work. The Methodist Church is on the right. The pew in which the Grants sat while attending the church is marked with a brass plaque. Founded in 1828, this 1857 church is the congregation's third building. In the center stands the Fire House No. 1, constructed in 1851. The fire bell steps next to it were originally made of wood. The 1850s Stitz House is on the left. (Photo Galena Historical Museum.)

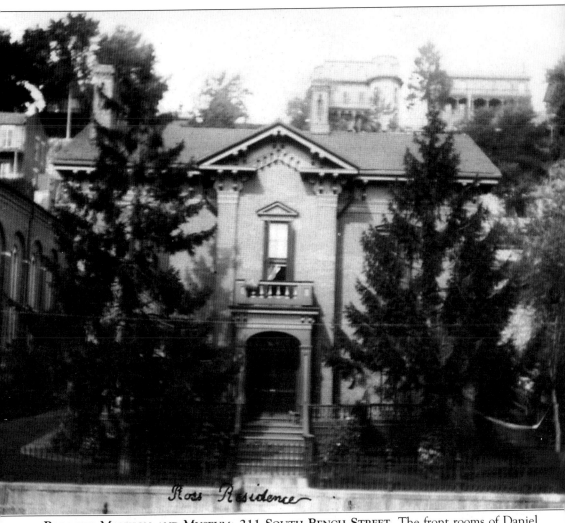

Ross Residence

BARROWS MANSION AND MUSEUM: 211 SOUTH BENCH STREET. The front rooms of Daniel Barrow's grand Italianate house, built in 1858–1859, have the original high ceilings, medallions, faux grained woodwork, marble fireplaces, and curved stairway. Daniel was a lumber merchant and served on the Galena City Council in 1849, 1854, and 1856. In 1922, the Odd Fellows purchased the building and added a side entrance and two large auditorium rooms. After the building was purchased by the City of Galena in 1938, the front two rooms were used as city hall, with the rest developed as a museum by the Galena-Jo Daviess County Historical Society. Fascinating exhibits include early mining and smelting exhibits and an actual lead mine that existed behind the museum for over 150 years. Steamboating, Indian life, early agricultural practices, and antique toys, dolls, clothing, and household artifacts illustrate Galena's historic past. General U.S. Grant, the Civil War, and the lives of the nine Union generals who served with Grant are vividly portrayed. The book shop offers a variety of books about history, styles, and the lives of Galena's early citizens. The museum is open from 9:30 a.m.–4:30 p.m. seven days a week, with the exception of major holidays. To arrange for tours, including Main Street walks, and to ask questions, call 777-9129. (Photo Galena Historical Museum.)

St. Michael's Catholic Church and Parsonage: 225 South Bench Street. Organized by Father Mazzachelli in 1832, the church served the many Irish families in Galena. After the original building was destroyed by fire in 1856, this impressive building was built, opening in December of 1863. Father Mazzachelli is credited with designing the Romanesque Revival church that we see today. The Queen Anne parsonage (on left) was built in 1896 at a cost of $5500. (Photo Spurr Collection.)

Dr. Newhall Residence: 235 South Bench Street. A belvedere tops the grand Italianate Newhall residence, constructed in 1848. Dr. Horatio Newhall was one of Galena's earliest physicians and drug store owners. Coming to Galena in 1827, he was called "a puritan, editor, scholar, and eminent doctor" and a man of "marked ability and stern integrity." He was involved in many early community activities including the library board, Temperance Society, Chamber of Commerce, and the *Galena Advertiser*. The building has been a funeral home for more than 80 years. (Photo Spurr Collection.)

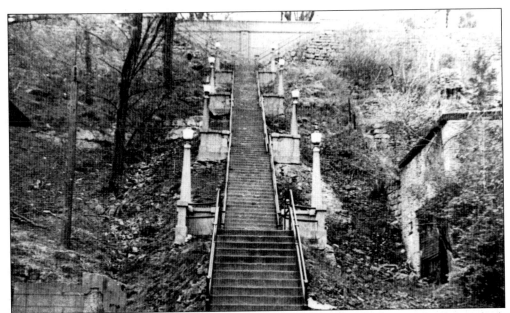

OLD HIGH SCHOOL STEPS. Many a student has a story to tell about the high school steps, built of wood in 1845, and reaching from Bench Street to the high school on Prospect Street. During J.H. Billingsley's term as Mayor of Galena from 1917–1921, the steps were remade in concrete, with a classic wall and railing at street level on Prospect Street. In the late 1990s, the Galena Foundation received an Illinois Historic Preservation Award for restoring the steps and lights to their former beauty. (Galena Historic Sites Office.)

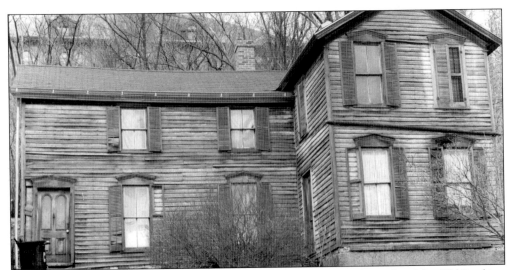

OLD BANKING HOUSE: 403 SOUTH BENCH STREET. Underneath the walls of the Old Banking House lies an 1826 log cabin. Authentically restored in the early 1970s, the house looks much as it did during its early years, even though it has been through some hard times. In 1835, when it was the home of William Bostwick, head cashier, it was used to house the State Bank of Galena. In 1841, the south half burned. The restored house appeared in the *Country Home* and *Good Housekeeping* magazines in the 1980s. (Photo Marsh Collection.)

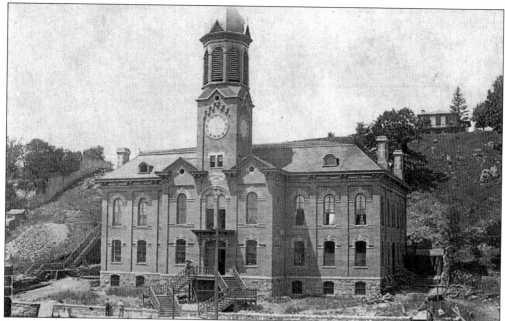

FEEHAN HALL: 413 SOUTH BENCH STREET. Constructed in 1886 as St. Michael's Annunciation School, the building was named for Bishop Feehan of Chicago. The two-story Romanesque Revival building featured a second-floor dining room and auditorium and was "the scene of many good plays." After the school closed in the 1960s, the building became the Galena Art and Recreation Center (1967) and offers recreational activities for all ages. (Photo Galena Historical Museum.)

WESTMINSTER PRESBYTERIAN CHURCH: 513 SOUTH BENCH STREET. Organized in 1846 as the South Presbyterian Church, the new congregation occupied a small frame church opposite where this brick church building now stands. The restored Classical Revival sanctuary features Corinthian columns, intricate stained glass windows, and the original stenciled organ pipes. Now called the Westminster Presbyterian Church, the congregation recently reconstructed the steeple, which had been destroyed in a storm. (Photo Spurr Collection.)

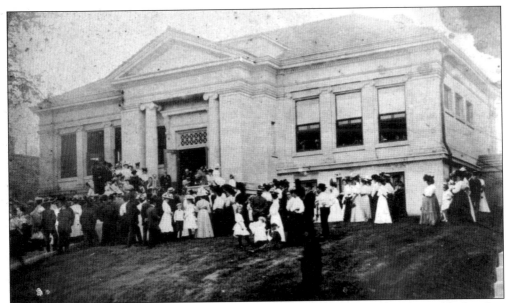

GALENA PUBLIC LIBRARY: 601 SOUTH BENCH STREET. Anna Felt was 35 years old when her father, Benjamin Felt, founded the Galena Public Library and Reading Room. She had been on the original library board, formed in 1894, and was dedicated to the cause until she died at age 93. Benjamin Felt, a prominent retail and wholesale grocer, shared the cost of the library with Andrew Carnegie. Anna asked her father to stipulate that four of the nine board members must be women. The classical Roman statues in the main room were purchased by Miss Felt during her travels in Europe, and presented to the library. (Photo Mueller Collection.)

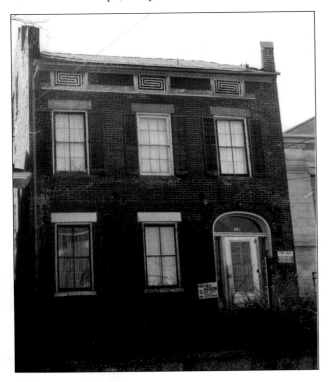

STAHL HOUSE: 603 SOUTH BENCH STREET. Built in 1842 by Frederick Stahl as a gift to his wife, Alice McLean, this elegant house is Federal in style. If you look at the back, you can see that the northern section of the house was demolished in 1906 to allow for the building of the library. For years, the house contained five apartments, but was restored to its original floor plan by the present owner in 2002.

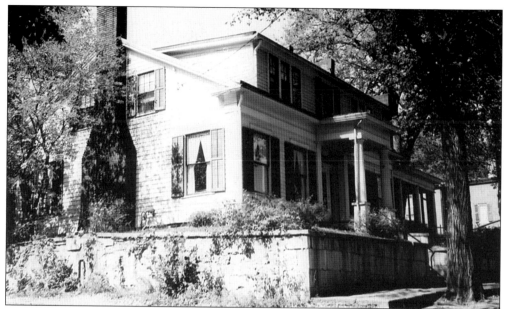

DAVIS HOUSE: 605 SOUTH BENCH STREET. The graceful Greek Revival house on the corner of Bench Street and Magazine Street was built about 1832 by David Davis, an early surveyor. Captain John Weber, an early occupant from 1836–1840, was the assistant superintendent for the U.S. agency which governed lead mines. In 1900, James Young owned the house. (Photo Galena Historic Sites Office.)

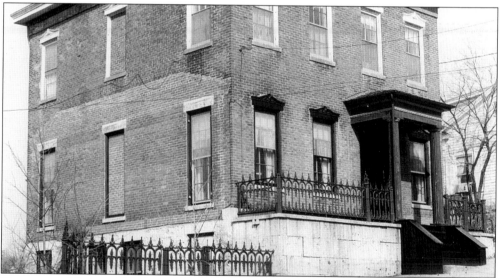

HEMPSTEAD HOUSE: 602 SOUTH BENCH STREET. Built in 1851 at a cost of $4500, the house is Greek Revival in style. William Hempstead, who arrived here in 1827, was a collector of U.S. revenue. The house remained in the family until it was sold to Louis Shissler by Mr. Hempstead's granddaughter, Mrs. Manuel, in 1869. Shissler, who first came to Galena in 1841, graduated from Harvard with a law degree and returned to our city in 1857. He served as mayor in 1866 and 1867. From 1888–1977, the house was the parsonage for the Westminster Presbyterian Church. (Photo Galena Historic Sites Office.)

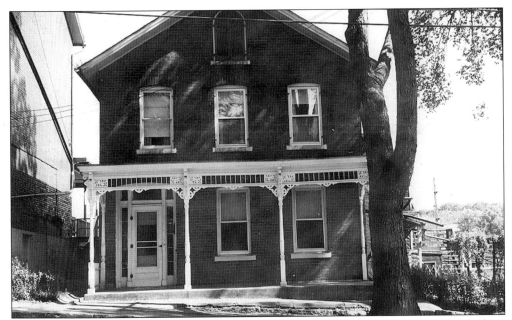

BENDER HOUSE: 614 SOUTH BENCH AVENUE. The Bender House is a rare example of a long chain of ownership by one family and its efforts to preserve and respect their family treasures. The present owners sleep in the same bed that Bob was born in. The Bender family moved into the house in the early 1890s. When Bob's father died, the Spurrs purchased the house and eventually moved back from Cedar Rapids. In the process of restoring the house they have uncovered many wonderful family and Galena treasures. (Photo Galena Historic Sites Office.)

DOWNTOWN. Jo Daviess County residents have always loved a parade, and Main Street is still the ideal place to have several of these events every year. In the 1890s, the float shown above won the top prize at the Lead and Zinc Carnival. Any holiday—Halloween, St. Patrick's Day, the Fourth of July—presents an opportunity for one of Galena's unique parades. They not only represent our nation's past, but are lots of fun! (Photo Galena Historical Museum.)

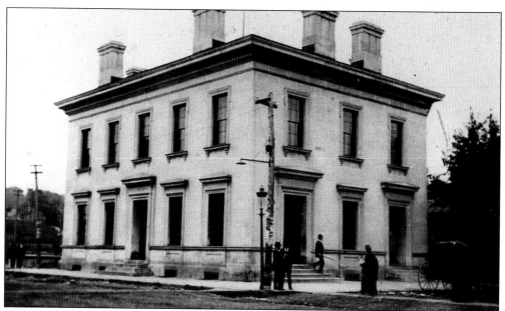

U.S. Customs House and Post Office: Commerce Street. One of Northern Illinois' most historically significant and substantial buildings, this Renaissance Revival federal building was constructed of Nauvoo limestone in 1857. The construction superintendent was Eli Parker, a talented Seneca Indian engineer. Goods brought up river were registered at the Customs House. The interior has changed little and the second floor still has its original rooms with four white marble fireplaces. (Photo Galena Historical Society.)

The Market House: Commerce Street. Constructed in 1845 to serve as a market house, this elegant Greek Revival building featured the City Council Chambers on the second floor. Its primary purpose was to bring together the venders and farmers to sell their wares, allowing the shoppers to go to one place instead of "having to traverse half of the city to make some paltry purchase." Now a State-owned museum, the building houses historical exhibits of the highest quality and is open to the public. (Photo Galena Historical Society.)

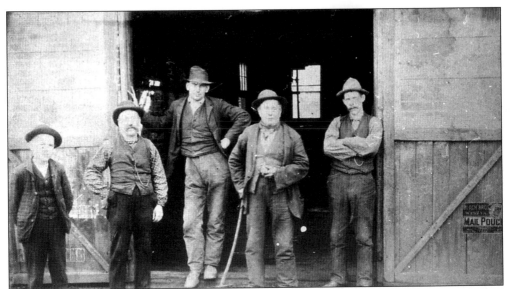

RICHARDSON'S BLACKSMITH SHOP: COMMERCE STREET. The newest museum in Galena represents the importance of the blacksmith in the community of the past. Built in 1897, it has now been completely restored by the Galena Historical Society. Most of the equipment used by Willard Richardson, the last blacksmith, is on display. This is a rare opportunity to view an authentic blacksmith's shop. (Photo Galena Historical Society.)

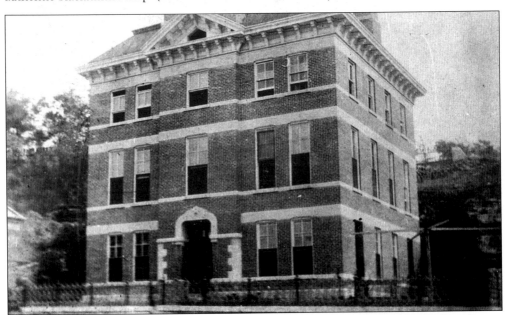

OLD COUNTY JAIL: 319 MEEKER. Sitting high on the hill next to the Jo Daviess Courthouse, the four story Second Empire brick jail, built in 1878, cost $16,000. The building was not only a jail, but also the home of the sheriff and his family. The jail, located on the third and fourth floor, was separated from the first two floors by a ceiling of iron beams and arched brick, covered with wood planks and an iron plate floor. The building has recently been creatively renovated into a home on the first two floors and apartments on the top two floors. (Photo Galena Historical Society.)

Five

SPRING STREET (ROUTE 20) REBORN

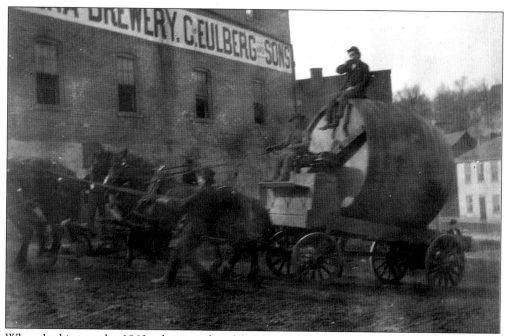

When looking at the 1960s photographs of Spring Street, it is obvious that many remarkable and impressive restorations and renovations have occurred during the past 40 years. This represents a tremendous effort by Galena property owners, and the results are evidenced in the revitalized picture we see today. The area has recently been designated The Galena Artists Row. You will enjoy taking a closer look at these unique historic buildings. In the 1820s and 1830s, log cabins were built along the road. In the 1850s and 1860s, a business district was developed along the south side. Dominated by two impressive and substantial breweries, it also included grocery stores, saloons, bakeries, a hotel, and a blacksmith shop. Spring Street was named after a spring near the bridge that is still active. The photo above was taken in the 1880s, in front of the Galena (Eulberg) Brewery, originally the Fulton Brewery. It is now the Galena Art Center at the corner of Spring and Prospect Streets. We hope you will take time to look at the photographs, read the stories, and marvel at the vibrant character of this street as it is today. (Photo Mueller Collection.)

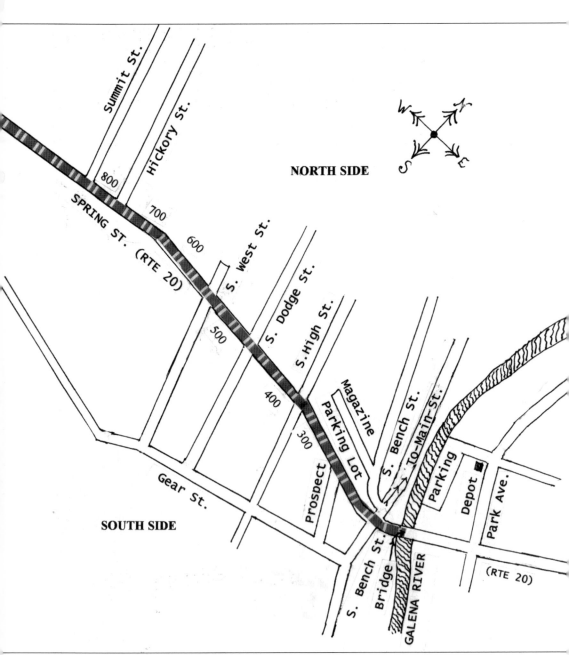

SPRING STREET (ROUTE 20) TOUR. You can start your tour of Spring Street at the public parking lot on the north side, just after you pass the intersection on the west side of the bridge. To get a closer look at other places along Spring Street, you can park on the side streets on the north side and walk along the Spring Street sidewalks.

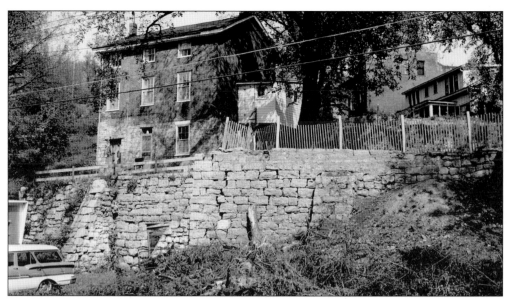

DESMOND HOUSE: NORTH SIDE. The setting of the Desmond House illustrates the drama provided by the limestone walls and steps of Galena. The Desmonds—Daniel, a drayman, and Patrick, a laborer—arrived in Galena in 1836 from Ireland. Daniel built this house in 1849. It is often called "The Pilot House" after Patrick's son, William, a river boat captain in the 1870s and 1880s. It has been fully restored, including an old fashioned kitchen, by the present owner. (Photo Galena Historic Sites Office.)

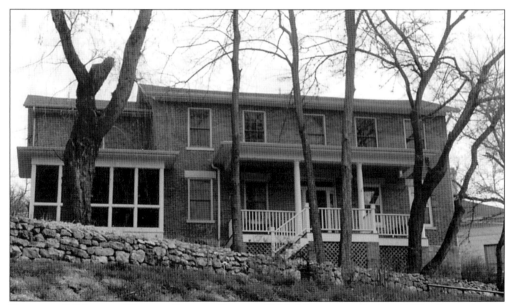

DEMPSEY-O'MALLEY HOUSE: SPRING STREET (225 MAGAZINE STREET) The large elegant Federal style house overlooking Spring Street began life as a small, two-story cabin built in the late 1820s by John Stuckey. After several owners, it was purchased by Thomas O'Malley, a miner, in 1855. The O'Malleys built the brick, two-story main section of the house and continued the brick around the outside of the original structure, creating the impressive home you see today. (Photo Marsh Collection.)

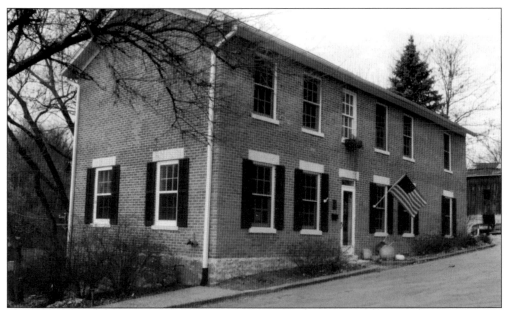

DEMPSEY-O'MALLEY HOUSE: SPRING STREET (225 MAGAZINE STREET). After Anthony Dempsey, a laborer, bought the house in 1886, it was occupied by three generations of his family. In the 1970s, it became Lolly's Toy Museum. When the present owners bought it, they had to use the back door on Magazine Street, because the front porch was gone. Consequently, they reconstructed the original classic columned front porch and replaced a small side porch with a spacious screened porch. (Photo Marsh Collection.)

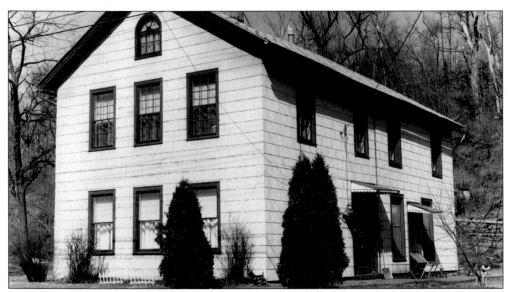

WEBER-MARTIN HOUSE (GREENBRIAR INN): 341 SPRING STREET. When John Weber, a mine superintendent, built this home in 1836, it was a two-room cottage. By the time W. Dickson bought it from A.M. Richardson in 1854, it had been significantly enlarged. In 1874, Christian and Mary Martin purchased the house. After Christian died in 1877, Mary made the house into two apartments. Velda Schoenfeld remembers living here as a young bride in the 1950s. (Photo Galena Historic Sites Office.)

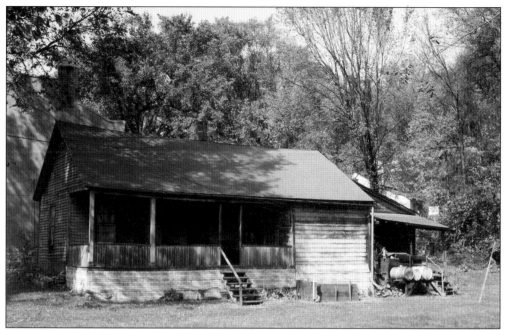

MORRISON HOUSE (GREENBRIAR INN): 347 SPRING STREET. Built about 1836 by Jesse Morrison, one of Galena's important early pioneers, the cottage shown above was in sad shape when this photo was taken. A merchant and farmer, Morrison was one of the founders of the Galena branch of the State Bank of Illinois and, in April 1839, was elected to the first Galena Board of Trustees. After he died, his wife, Adeline, lived in the house until she died in 1888. Pat Lowery restored the home. (Photo Galena Historic Sites Office.)

DEASE-BOSTWICK-CUMMINGS DOUBLE HOUSE (GREENBRIAR INN): 349–351 SPRING STREET. John Dease, who built this double house in 1854, was a local saloon owner. William Bostwick, a prominent lawyer and judge, purchased it for a rental in 1862. Alonzo Cumings, also a successful lawyer and active citizen, bought it in 1878. In the 1950s and 1960s, it was owned and lived in by Dey Johnson and his wife, Mossie. Pat Lowery restored it as a bed-and-breakfast in the 1980s. (Photo Galena Historic Sites Office.)

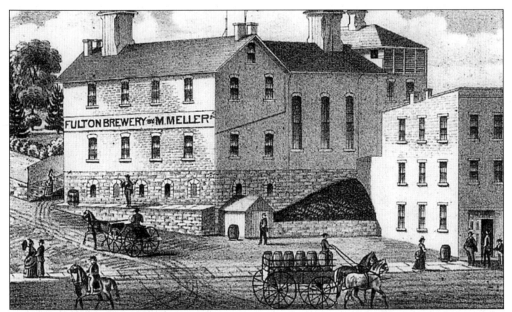

FULTON (MELLER-EULBERG) BREWERY (GALENA ART CENTER): 601 SOUTH PROSPECT STREET. The drawing above appeared in the 1878 *History of Jo Daviess County.* Built by Mathias Meller in 1867, the imposing red brick building has had several additions. Born in Germany, Meller came to America and Galena in 1849 with the occupations of baker, brewer, and distiller. In 1853, he became one of the adventuresome Galenians who joined the emigration to California, hoping to make his fortune in the gold fields. In 1858, he returned, and in 1867, built this large brewery.

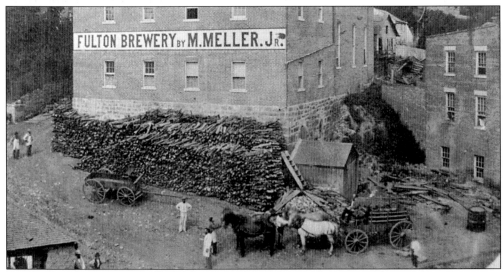

FULTON (MELLER-EULBERG) BREWERY (GALENA ART CENTER): 601 SOUTH PROSPECT STREET. After a fire in 1882, Peter Eulberg and Sons, from Dubuque, Iowa, leased the building and eventually purchased it. Kraft Foods, owner of a cheese plant on Commerce Street, had a condensary here during the 1940s and 1950s. Many Galenians remember the building in the 1980s and 1990s, when it was an antique mall with three floors of unique treasures. It has recently been rehabilitated as the Galena Art Center. (Photo Mueller Collection.)

BERGER-MILLER BUILDING (RENAISSANCE SUITES): 324 SPRING STREET. This classic brick building was built by C. Berger in 1857. In the 1860s, Mathias Meller, owner of the brewery next door, used the first floor as a saloon. That use continued after the Eulbergs leased the brewery in 1882. By the 1950s, Leo Miller had opened Miller's Supermarket on the first floor while his family lived on the second floor. The Stone Mill Antiques shop was located here in the 1970s. (See next page for restoration details.) (Photo Galena Historic Sites Office.)

WEBER-WEINSCHENK BUILDING (RIVERBOAT SUITES): 328 SPRING STREET. Englebat Weber built this building in 1856, using the first floor for his grocery store and tavern and the second for his family living quarters. By 1885, John Weinschenck operated a saloon on the first floor, dealing in wines, liquors, and cigars. Edward and Lucile Casserly, owners of the Trading Post, lived here in the 1950s, after the building had been converted to two apartments. (See next page for restoration details.) (Photo Galena Historic Sites Office.)

SPRING STREET 300 BLOCK. Terry and Victoria Cole restored the three buildings at 324, 328, and 330 Spring Street. As you can see by the photos, the changes have been dramatic. For fifteen years, 324 was Victoria's paint and decorating store. When the Coles purchased the small wooden building at 330, it was in use as a rock museum. The Coles moved it several feet, rehabilitated it, and made it into the office for their construction business. Behind the buildings is a spa located in an old brick root cellar with a vaulted brick ceiling. A fountain and manicured gardens complete the picture. (Photo Marsh Collection.)

FARMER'S HOME HOTEL (FARMER'S GUEST HOUSE): 340 SPRING STREET. Imagine the Farmer's Guest House with doors wide open, farmers selling their wares and shoppers going to and fro carrying packages. Farmers who came from a distance could stay upstairs. Casper and Balzar Vogel, bakers, built the combination bakery, market, and boarding house in the Italianate style in 1867. Members of the Vogel family continued to live in the building until 1978, when Carrie Vogel went to a nursing home. (Photo Galena Historic Sites Office.)

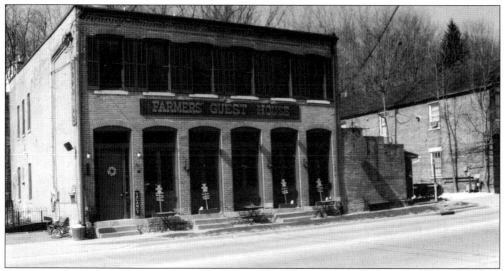

FARMER'S HOME HOTEL (FARMER'S GUEST HOUSE): 340 SPRING STREET. Carrie Vogel operated the Old Store Antique Shop, and lived here all alone for several years. Kristianson and Mansburger purchased the building in 1985. Restoring the first floor as a restaurant, they began working on the upstairs rooms. Health and building department troubles ensued, and the building was sold to the Cummings, who completed the necessary compliance work. The present owners, the Farlows, restored the brick exterior, installed the shutters, and added many charming touches. (Photo Marsh Collection.)

NATH'S GARAGE: 334–336 SPRING STREET. Many Galenians remember this narrow brick building and concrete garage as the home of Nath's Garage from the 1940s to the 1970s. Fred and Gladys Nath lived upstairs during that time. In the 1850s and 1860s, the original two-story brick building was the business and home of Christian Keohler, a blacksmith and carriage and wagon maker. The concrete addition was built by the Naths. (Photo Galena Historic Sites Office.)

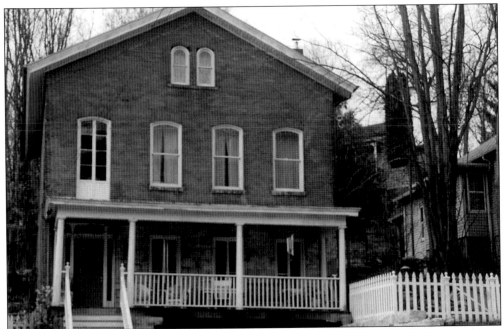

SCHWAB HOUSE: 340 SPRING STREET. The Schwab house began life as a barrel-vaulted limestone cellar, probably for brewing or storage. During the 1860s, the top two floors were added when the building became a residence. Lawrence Schwab, who lived here at that time, owned a wholesale and retail wine and liquor shop at Main and Spring Streets. (Photo Marsh Collection.)

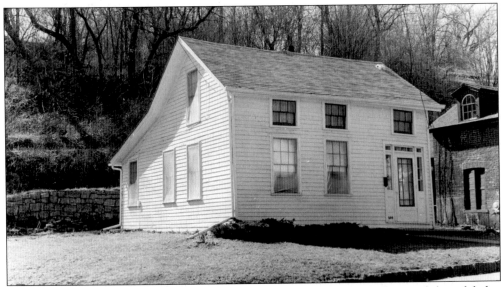

HARTWIG-NIEMAN HOUSE: 400 SPRING STREET. The six-over-six windows and the sidelights and transom surrounding the front door help determine the age of this home as a late 1850s Greek Revival house. It was built by Charles Hartwig, a teamster, in 1857. Later he was a janitor at the post office. By the turn of the century Clemens Nieman, one of several brewers who lived along Spring Street, and his wife, Mary, lived here. (Photo Galena Historic Sites Office.)

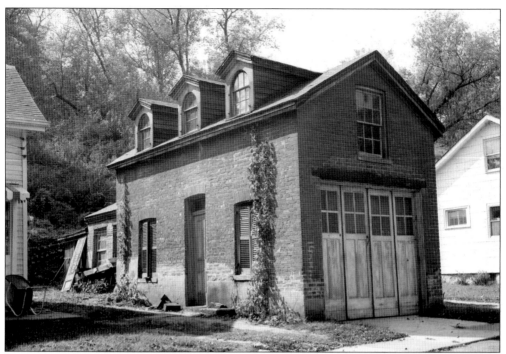

DOPLAR CARRIAGE HOUSE (MILAGO JEWELERS): 402 SPRING STREET. Many Galenians will remember this little building as Larsen's Book Store. Larsen removed the original carriage doors and installed the present large multi-paned window. Built in 1858 as a stable for the Doplar House to the west, it features three dormers on the east side. Gottlieb and Mary Geiger owned it at the same time as they owned the house. (Photo Galena Historic Sites Office.)

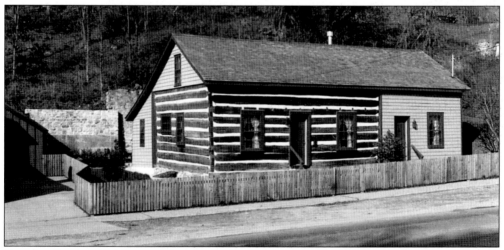

DOPLAR CABIN: 406 SPRING STREET. Joseph Doplar came from Germany to Galena in 1836, building this log cabin for his family in 1838. A tailor, he made uniforms for riverboat officers. Records show that Doplar lost the east 20 feet of his property over the 1844 presidential election, when he backed Henry Clay. Deeply in debt, he sold the cabin itself to Andrew Hanft in 1848 for $500 and left town. Terry Cole restored the cabin to its original appearance in 1983. (Photo Galena Historical Museum.)

PARKER STREET. Originally running northeast from Spring to Magazine Street, Parker was replaced with a sidewalk several years ago. Marie Henning Knautz posed for this photo in about 1910. If you look beyond Marie, you can see the houses on the south side of Spring Street. (Photo Alfred Mueller History Room, Galena Public Library.)

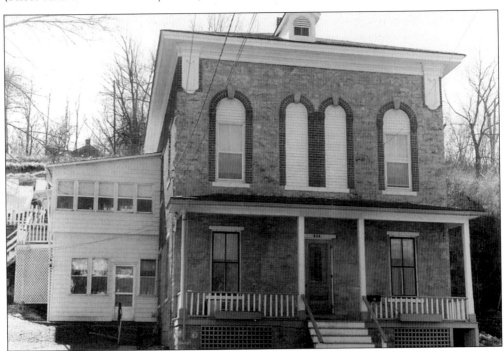

CHILD'S HOUSE (ABE'S SPRING STREET GUEST HOUSE): 414 SPRING STREET. Built in 1876 as the ice house for the City Brewery, this elegant stone and brick building was converted to a home for saloon owner Sherman (Elizabeth) Childs. Their daughter, Florence, married Abe Gerlich, a miner and carpenter, and they moved to Muddy Hollow. When this house came up for sale, the Gerlichs were able to buy the home where Florence grew up. After she died, Abe lived here alone until 1971 when the present owners bought the house (Photo Galena Historic Sites Office.)

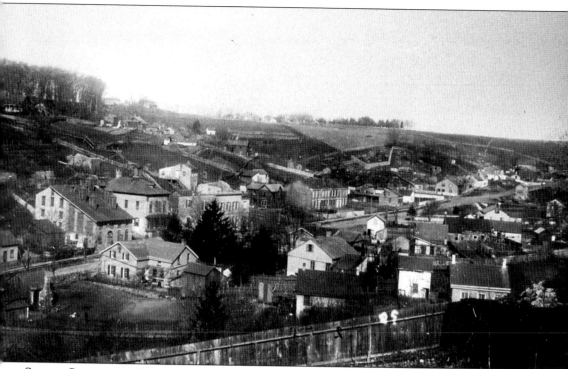

SPRING STREET 400 BLOCK. Looking southwest, the Doplar Cabin is in the lower left of the photograph. Next to it are the buildings owned by the City Brewing Co. The large brewery building (tallest) was demolished many years ago, leaving the rock storage rooms below embedded in the hill. These were preserved when the new building was built in 2002. The ice house, in the center, was built in 1876. The existing City Brewery Building is to the right of that. (Photo Galena History Museum.)

SPRING STREET 500 BLOCK. The right half of this *c.*1890 photo shows the 500 block of Spring Street, south side. The dark house is the Henry Henning House. Next door, to the west, you can see the Greek Revival Marsden Row House with its row of windows and doors. Mary Melvill's house is next, with the Rellis House on the end. (Photo Galena Historic Sites Office.)

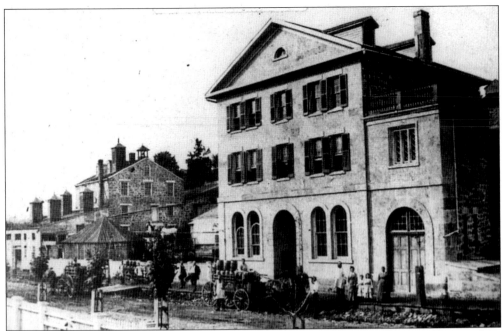

CITY BREWERY (STONE HOUSE POTTERY AND GALLERY): 418 SPRING STREET. The top floor and gabled roof of the city brewery were lost in a fire in 1893. The German English School was located here at the time. The building on the left was also part of the brewery, as well as the site of the Hardenburg Broom Factory in the 1870s. Hardenburg once painted his fence red, white, and blue, to the amusement of the community. (Photo Galena Historic Sites Office.)

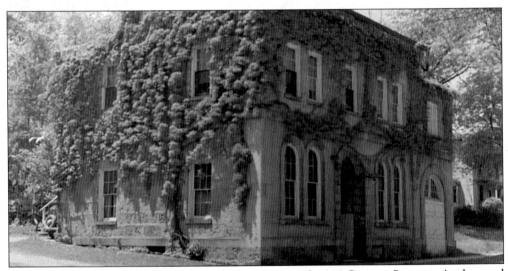

CITY BREWERY (STONE HOUSE POTTERY AND GALLERY): 418 SPRING STREET. Ageless and impressive, this rare stone building, built by Conrad Wetzel in 1850, was originally named the Fulton Brewery. After Wetzel passed away in 1856, his wife, Maria, married his assistant Rudolph Speier. Speier renamed it the "City Brewery." The building was restored by Charles and Sandy Fach, who bought the building in 1971 and house their pottery studio on the first floor. The second floor has been made into an inviting apartment. The pottery studio is well worth visiting. (Photo Galena Historic Sites Office.)

JOAQUIN HENNING HOUSE: 407 SPRING STREET. Joaquin Henning came to the United States in 1855 from Germany and to Galena in 1861. He worked in the Mahony and Rochford Store. His only child, Henry, later lived across the road at 500 Spring Street and was a well-known local photographer. When Joaquin died in 1895, his pallbearers were his neighbors and members of the tight German society that existed along Spring Street. His great-granddaughter still lives in the house. (Photo Galena Historic Sites Office.)

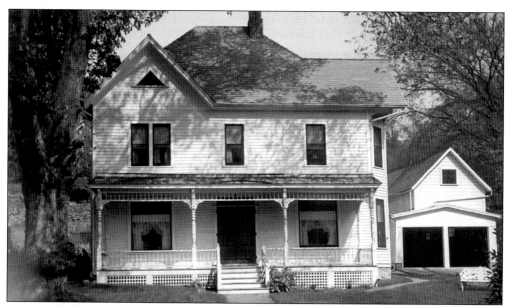

EINSWEILER HOUSE: 411 SPRING. The original rooms of this home still exist behind the elaborate Queen Anne front rooms added by H.C. Beil about 1890. Henry Muchow, a retired farmer, lived here until 1930 when the Frank Einsweiler family moved in. He owned the Leadmine Foundry, which still exists at 100 Commerce St. Frank's son, John, and his wife, Virginia, inherited the house in 1942. Their son, who still lives here, remembers moving into the house when he was six years old. The house is beautifully maintained. (Photo Galena Historic Sites Office.)

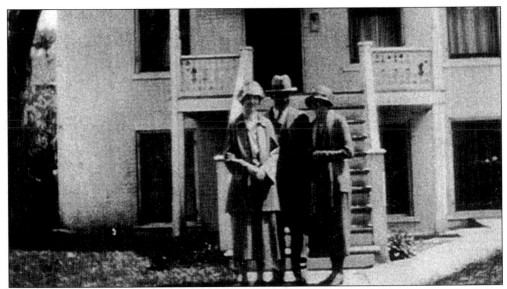

ERBE-BURROWS HOUSE: 413 SPRING STREET. Charles Erbe, a shoemaker, occupied a home at this location from 1858 until 1874. Miss Daisy Erbe, his daughter, was still living here in 1914. The original log cabin is under the present façade and is covered with clapboards. The front wall is constructed of brick. The early front porch, shown above, has been replaced. In the 1930s, Frank Einsweiler bought the house for his daughter and son-in-law, William and Una Burrows. (Photo Einsweiler Collection.)

PHILIP FRIESENECKER HOUSE: 507 SPRING STREET. Philip and Margaret Friesenecker, prominent grocery store owners, built this fine example of a Queen Anne home in 1891. Born in Galena and raised in the family home on Third Street, Philip took over the grocery business from his father, Mathias. They sold, among other things, produce, tobacco, cigars, crockery, and animal feed. He was also an agent for four fire and tornado insurance companies. (Photo Galena Historic Sites Office.)

BIRGER-HOMRICH HOUSE: 519 SPRING STREET. The four vertical panes in the top of each window and the porch posts and decoration indicate that the Birger House was built in the early 1920s. Ernest and Helga Birger were the owners of the Birger Dry Goods Company at 117 North Main Street. The Homrichs, who lived in the house for more than twenty-five years, moved in during 1930. He was a teller at the First State and Savings Bank. (Photo Galena Historic Sites Office.)

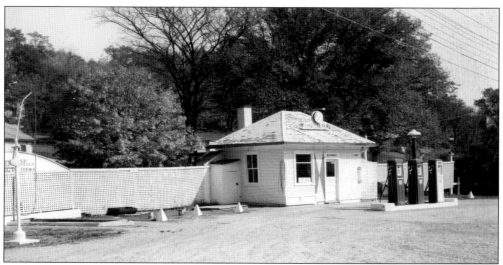

PHILLIPS 66 STATION: 600 BLOCK SPRING STREET. Look closely among the trees and you can still see the abandoned Phillips 66 building. The pumps and the fence are gone, but the small square building remains. Red McGuire, who lived across the street, established the station in 1935 and ran the business until it closed in the 1970s. The nearby corner of Spring and West Streets was the location of John Robinson's lime kilns during the 1850s. (Photo Galena Historic Sites Office.)

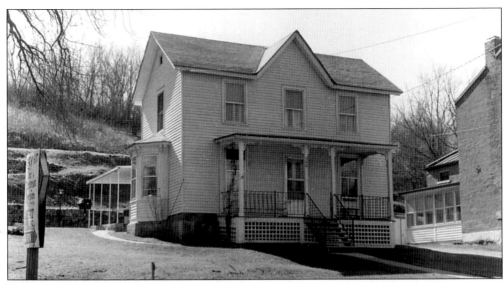

HENRY HENNING HOUSE: 500 SPRING STREET. Henry Henning, described as "the talented photo artist," moved into this house soon after it was built by carpenter Charles Peters in 1891. Born in Galena in September 1863, Henry worked at several local jobs before moving to Milwaukee, Wisconsin, where he learned the photography business. Returning to Galena in 1885, he opened his own photography studio and became quite successful. (Photo Galena Historical Sites Office.)

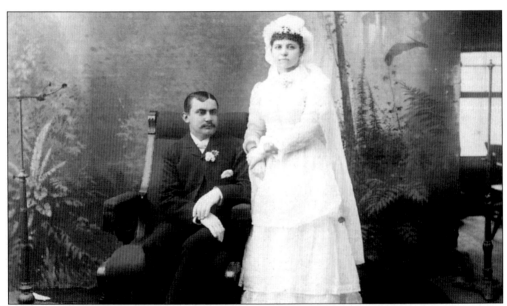

HENRY AND CAROLINE HENNING. Henry and Caroline Henning are shown here on their wedding day in 1886. They later had four children, Mamie, Ida, Henry, and Arthur. The photos he took of almost all of Galena in the 1880s and 1890s have survived him, leaving a valuable record of the city during those years. Sadly, he died in 1902 at the age of 39 from Bright's Disease. Caroline lived in the house above until she passed away in 1949. (Photo Galena Public Library History Room.)

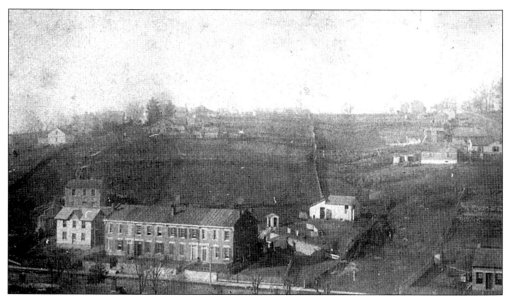

MARSDEN ROW: 504–510 SPRING STREET. Peter Marsden built the Greek Revival row house in 1855 for his relatives. The units were first owned by Stephen Marsden, who made his fortune when he discovered the famous Marsden Mine while cleaning out a spring. Digging back further, he found a lead-filled cave 30 feet in diameter. Stephen sold several of the row units to Marsden family members, who lived here through the 1960s. In the 1980s, Jeff Running restored the three eastern units. (Photo Mueller Collection.)

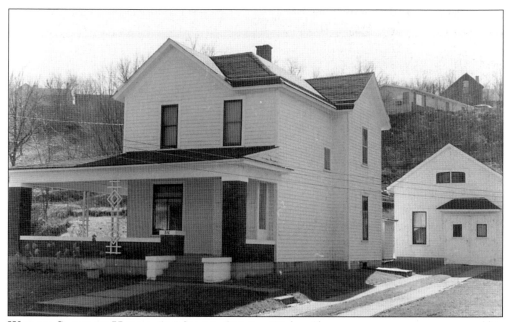

WALTER SLATTERY HOUSE: 516 SPRING STREET. Walter Slattery, a cement contractor, and his wife, Mary, were the first owners of the large Craftsman style Foursquare house with the solid brick railing and pillars. He was one of ten children of Michael Slattery, who built the house at 624 Spring Street. He was Galena's first cement contractor and built many of the sidewalks throughout the city. (Galena Historic Sites Office.)

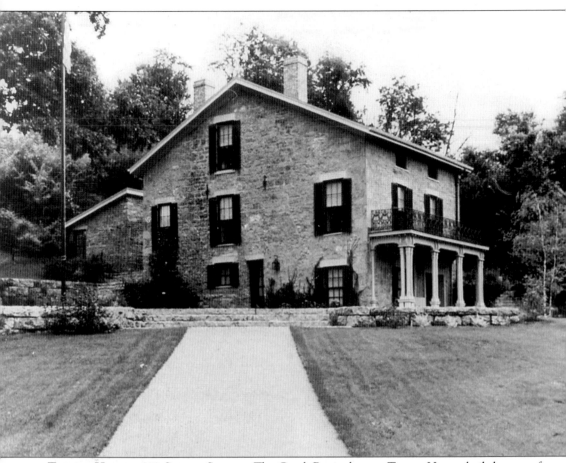

TURNEY HOUSE: 612 SPRING STREET. The Greek Revival stone Turney House, built by one of Galena's most prominent pioneers, has seen a variety of ups and downs during its long life. Coming to Galena in 1826, John and Nancy Turney built their elegant stone house in 1835. John Turney, Galena's first lawyer, was a leading proponent of Galena's incorporation and served on the board of trustees, as city attorney (1842 and 1843), member of the land commission (1836), first school committee (1838), and trustee of the Galena Library Association (1835), as well as working full time as a lawyer. Sadly, he died at a young age in 1844. The house served a variety of uses after that time, including a soap and candle factory, a home for poor families, and a bakery. In 1863, after the house suffered a serious fire, Captain Thomas Woodward, a river pilot, purchased and restored the home. The next owners, the Charles Geigers, added the front porch, moved from the house at 609 South Prospect Street. In 1968, the house was sold to Ralph Benson who restored it to its original charm and opened it for tours. The house is now the office of Cox and Ward, attorneys. (Photo Mueller Collection.)

SLATTERY FARM: 624 SPRING STREET. The lithograph above, taken from an 1889 Galena history book, dramatically illustrates that the Slattery Farm has changed little since it was built in the 1850s. Coming from Ireland, Michael Slattery first settled in Jackson County, Iowa. He came to Galena in 1852. He was a dealer in hay, grain, wood, and coal, with his business headquarters on Main Street. The Slatterys had ten children. Mr. Slattery was called "an uncompromising Democrat." (Photo Galena Public Library History Room.)

ROBINSON FARM (THE GALENA CREATIONS VILLAGE SHOP): 700 SPRING STREET. John Robinson built the brick portion of this house soon after purchasing the property in 1854. The stone section of the house appears to have already existed. Robinson built several rental properties, including the house the Grant family rented in 1860–1861. He was also a lime burner, with kilns across the street. Peter and Margaret Moran, who had come from Ireland in 1848, purchased the house in 1865. The property has been restored as a charming shop. (Photo Marsh Collection.)

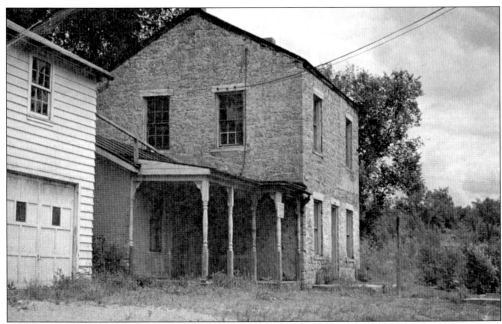

KOEHLER HOUSE: 809 SPRING STREET. When William and Catherine Peterson fell in love with the 1853 limestone Koehler House in 1988, it didn't matter that it didn't have any heat, indoor plumbing, or running water. Most of the interior had been stripped down to the rock walls. In addition, the outhouse door wouldn't close. They bought the house anyway, for $5,000. Their transformation was so remarkable that they were able to display it during the 1992 Presbyterian Home Tour. (Photo Galena Historic Sites Office.)

WEST GALENA DAIRY (O'CONNOR AND BROOKS CO.): 901 SPRING STREET. The West Galena Dairy, built in 1926 by Ben and Alma Knautz, is remembered fondly, especially for its delicious ice cream. During the early years of television, Dick Knautz operated Dick's Television Service in the east half. He was known for helping high school students in Mr. Pickett's class with their difficult electrical projects. It has been recently refurbished with a very attractive front façade and new windows. (Photo Galena Historic Sites Office.)

Six

QUALITY HILL
A SPECTACULAR VIEW
FROM PROSPECT

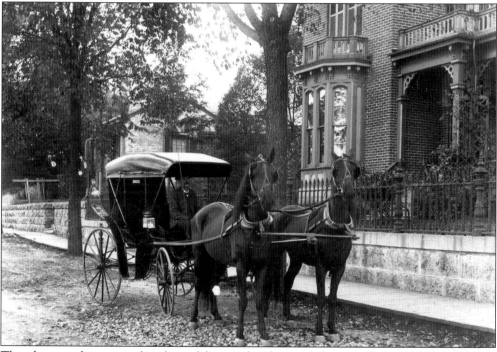

The sharp and precise clip-clop of horse's hoofs sounded up and down the undulating pavements of High and Prospect Streets as stylish buggies made their way home to Quality Hill from the owners' various businesses in Downtown Galena. On a Sunday the whole family, dressed in their best finery, could be seen on their way to one of the churches on Bench Street, St. Matthew's on High Street, or St. Mary's on Franklin Street. The families who built the elegant houses on Prospect and High Streets were the owners of many of the major stores and wholesale houses that helped drive Galena's economy from the mid-1850s into the 1870s. The area is called "Quality Hill" because of the grand houses and their visibility from all areas of the town. The house shown above is the Loveland House at 301 South Prospect Street. Amazingly, in the last 100–150 years, there have been few changes to the exteriors of the grand houses on Prospect and High Streets. The Historic Preservation Ordinance and Historic Advisory Board have been overseeing alterations in the Historic District since the mid-1960s. Almost all of these houses are beautifully and correctly maintained.

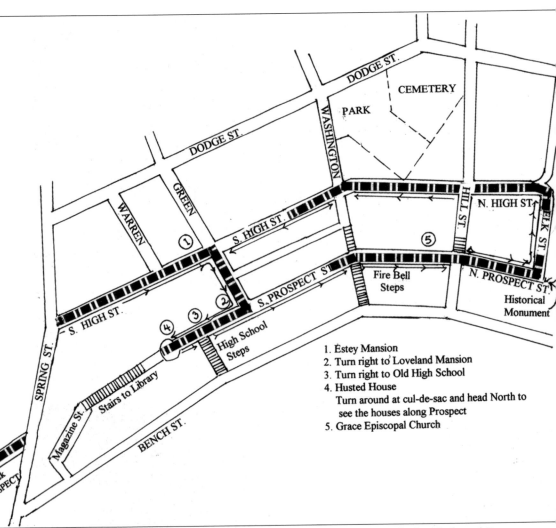

1. Estey Mansion
2. Turn right to Loveland Mansion
3. Turn right to Old High School
4. Husted House
 Turn around at cul-de-sac and head North to
 see the houses along Prospect
5. Grace Episcopal Church

HIGH STREET AND PROSPECT STREET MAP. The easiest way to reach the High and Prospect Streets tour is to take High Street to the north from Spring Street (Route 20). The Estey House, on the left, is the first house listed. Turn right on Green Street and right on South Prospect Street at the Loveland House. Pass the Old High School and turn around at the cul-de-sac. Head north along the length of South Prospect Street to Elk Street. Go left on Elk Street and left again on High Street Take High Street back to Spring Street (Route 20). At the corner of Prospect and Elk Streets is a rock monument, placed here by the D.A.R. in 1920, which states "Erected upon the site of the block house commanding the stockade which was used as a place of safety during the Black Hawk War, 1831–1832. The best way to see these impressive houses is to walk the streets. The houses along South Prospect Street can be seen from the new pathway along the west levee. Taking this walk provides a great view of both sides of Galena.

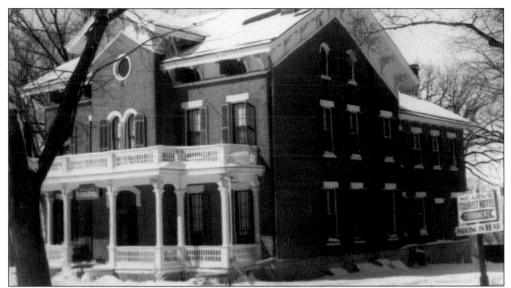

ESTEY HOUSE (VICTORIAN MANSION): 303 SOUTH HIGH STREET. Built by Augustus Estey in 1856, this grand Italianate mansion has 22 rooms and had an assessed value of $2,400, a large amount at that time. Augustus, who came to Galena in 1836, made his fortune as a lead smelter. In 1865 he became the first president of the Merchant's National Bank. An Estey daughter spent a winter in the White House with the Grant family. Miss Mary Estey lived in the house until she died in 1929. In the 1950s, the house was the Mearn's Tourist Hotel, one of Galena's first guest establishments. (Photo Galena Historical Museum.)

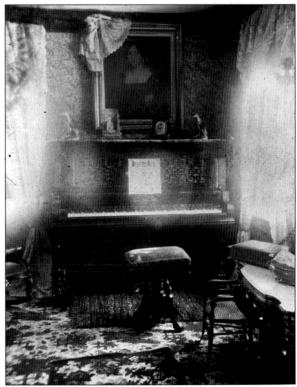

LOVELAND HOUSE: 301 SOUTH PROSPECT STREET. This is the formal parlor of one of Galena's impressive Italianate mansions, the Loveland House, built in 1870 by Daniel and Eleanor Loveland. Daniel, a very successful merchant, died in the house at the age of 81. The house was inherited by Jenny, their only child to have survived into adulthood. She and her husband, Dr. Thomas Wonderly, a local dentist, also lived here until they died in the 1930s. The house, later converted to apartments, was in a state of disrepair when the present owners bought it in 1988 and began the restoration process. (Photo Mueller Collection.)

OLD GALENA HIGH SCHOOL: 409–411 SOUTH PROSPECT STREET. The Richardson Romanesque high school sits like a crown on the top of the west hills of the city. It is especially beautiful at night, when the lights are on. The four-faced clock was the dream of the town when the building was built in 1905. The previous high school building burned to the ground in 1904. After this building was no longer in use as a school, Greenco Inc. successfully renovated it into condominiums. (Photo Spurr Collection.)

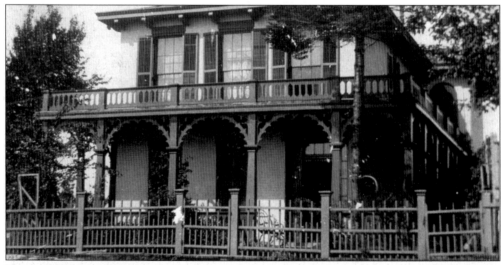

HUSTED HOUSE: 413 SOUTH PROSPECT STREET. Remembered by many as White House Antiques, this Italianate house was built in 1856 by Lyman Husted, a prominent dry goods merchant. The William Barretts owned the house from 1890 until 1938. They made several changes, including the replacement of the front porch. Kyle Husfloen restored the property in the 1980s including the gardens, and the only free-standing brick outhouse in Galena. Next door are the foundations of the African Methodist Church, a Black church built in 1844. (Photo Mueller Collection.)

110

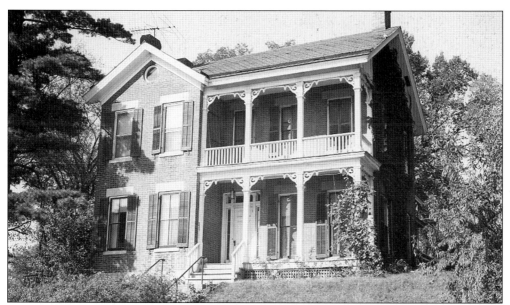

SEAL HOUSE: 225 SOUTH HIGH STREET. The *Galena Gazette* reported "Judge Richard Seal began his 25'x35' house, plus a wing which will be a spacious projection in front with a porch next to it" in 1871, at a cost of $4,400. The Seals had previously lived next door. Born in England in 1807, he came to Galena in 1836. He served as county clerk for the first board of supervisors in 1853. The Thomas Hughletts, who owned a large smelter, lived here by 1900. Their daughter, Anna, was the assistant at the Galena Public Library. (Photo Galena Historic Sites Office.)

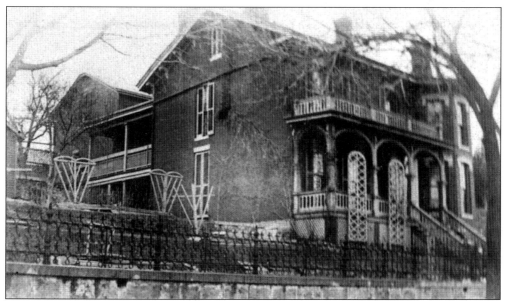

SEAL-FELT HOUSE: 219 SOUTH PROSPECT STREET. In the 1910s, a concrete block railing, the latest style at the time, replaced the original porch on this house, giving it a Craftsman appearance. Built in 1851 by Judge Richard Seal, the house was purchased in 1871 by Benjamin Felt, a prominent local merchant. He and his daughter Anna were best remembered for their generous contributions to the Galena Public Library. (Photo Galena Historical Museum.)

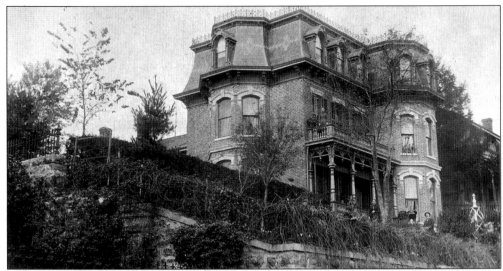

JOHN FIDDICK HOUSE: 215 SOUTH PROSPECT STREET. Originally built in 1859 in the Greek Revival style, the house was redesigned in the impressive Second Empire style in 1883, when the mansard roof and two-story bay windows were added. The third floor was made into a ballroom. In the 1910s, the porch was removed and a Craftsman style brick railing installed. After returning from the gold fields of California in 1852, John went into the dry goods business with his brother, William. Restoration has begun recently on the house, which stood empty for approximately 15 years. (Photo Mueller Collection.)

HAILE HOUSE: 209–211 SOUTH PROSPECT STREET. One of Galena's best examples of a classic Greek Revival double house, the house was built in 1856 by Asa Haile, a brick layer, contractor, and steamboat captain. He lived at the corner of High and Wight Streets. Several families occupied the house through the years, including John Ross, who was an agent for Henry Corwith in 1868, and William Hodson, a lawyer who was elected County Judge in 1887. Dr. B.A. Woodard, an osteopathic physician, and Charles Venable, a harness maker, were the owners in the 1910s. (Photo Galena Historic Sites Office.)

ST. CYR HOUSE: 207 SOUTH PROSPECT AVENUE. One of Galena's earliest merchants, Benjamin St. Cyr, arrived in Galena in 1828 to work in the mines. In 1857, he bought this house, and in 1900 his daughter Anna still lived here. The house has been altered several times, including a major remodeling into the present Craftsman Bungalow appearance in the 1920s. The Edward Blewetts lived here at that time, and the A.J. Millhouses resided here in the 1950s. (Photo Galena Historic Sites Office.)

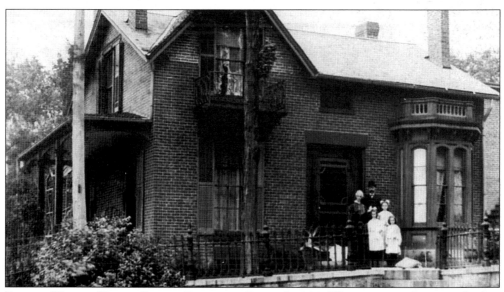

FOSTER HOUSE (FACES SOUTH PROSPECT STREET): 302 WASHINGTON STREET. Cephus Foster and his wife were the first occupants of this home, built in the late 1840s. They were principals of the Galena Female Academy across Hill Street. When Frank and Bessie Meller moved here about 1900, he was the secretary and bookkeeper of the Commercial Club, an early chamber of commerce. Later, their daughter Marguerite gave piano lessons in the living room. The house has been beautifully restored by the present owners. (Galena Mueller Collection.)

113

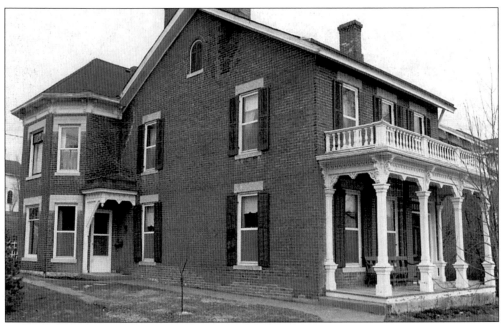

LAMBERSON HOUSE (GRANDVIEW BED-AND-BREAKFAST): 113 SOUTH PROSPECT STREET.
In 1870, the *Galena Gazette* reported "D.H. (Harvey) Lamberson has erected a large brick dwelling 22'x32', wing 16'x18'." He was the owner of the Sewing Machine Depot and sold Wheeler and Wilson sewing machines. He was also a partner with J.E. Jones in the photography studio of Jones and Lamberson, photographic artists, which claimed to produce "the highest style the art is capable of producing." Henry Wallace, listed as a gent's furnisher, lived here from the 1860s to the 1920s. (Galena Historic Sites Office.)

EDWARDS HOUSE: 111 SOUTH PROSPECT STREET. In August of 1877, "Ann Edwards purchased the Fawcett property . . . had the old building torn down, and erected an elegant brick residence," according to the *Galena Gazette*. She was the wife of the late John Edwards. Both were from England and were married in Galena. He died in 1868, and Ann Edwards moved here with their son Samuel, nine years later. An elegant, three-story, curving staircase rises from the entrance hall. (Photo Galena Historic Sites Office.)

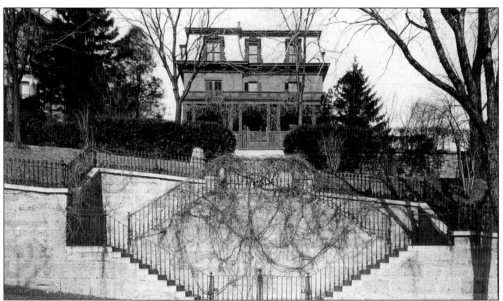

FELT MANOR: 125 SOUTH PROSPECT STREET. In 1874 the Lucius Felts remodeled their Greek Revival house into an elegant and impressive Second Empire mansion, complete with mansard roof. A dry goods merchant, he was also in estate management, a director of the Merchants National Bank, and one of the original incorporators of the Galena Gas Light Company (1853). The grand limestone steps and wrought iron railings were said to have cost about $40,000 to build in the 1860s and were christened "Felt's Folly" by a local wag. (Photo Mueller Collection.)

HAINES AND LEBRON HOUSES: 115 SOUTH PROSPECT STREET. The original house on the property, built by Andrew Haines in 1843, can be seen half way up the hill. Haines was in the mercantile business in the "up river trade." The Haines gave the lot in front to their daughter Martha for "one dollar and natural love" when she married Leo T. LeBron in 1894. The LeBrons built the front house in 1900. Leo and his son were jewelers and opticians and also specialized in Kodak cameras. (Galena Historic Sites Office.)

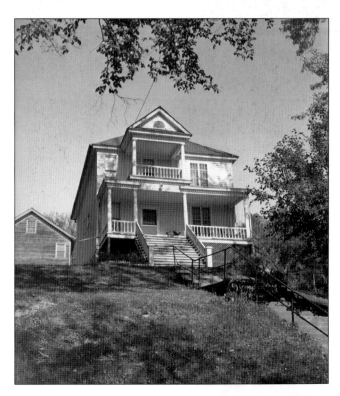

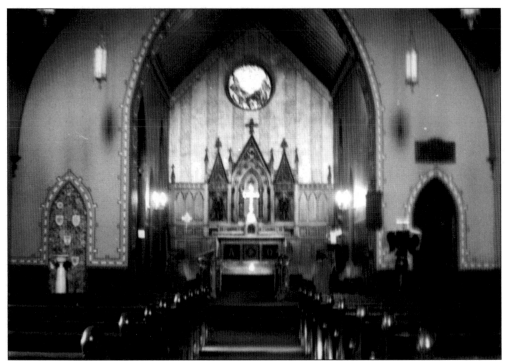

GRACE EPISCOPAL CHURCH: 105 SOUTH PROSPECT STREET. Grace Church is the oldest Episcopal Church in continuous use in the Chicago Diocese. The first service was held on the bank of the river in 1826. This impressive Gothic style limestone building was built between 1847 and 1849 and consecrated in 1850. The Erben organ, purchased in 1838 by Mrs. Alexander Hamilton, is still in use. The church recently completed a $450,000 restoration, accurate in every detail. (Photo Mueller Collection.)

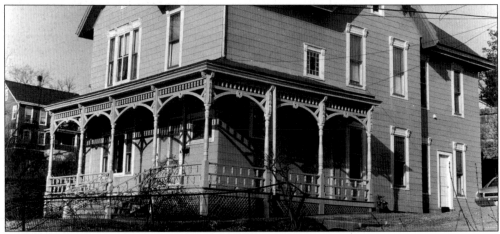

SCHAEFER HOUSE: 310 HILL STREET. Facing South Prospect Street, a delicate Victorian porch and elaborate gable fretwork decorate this Queen Anne Schaefer House, built by Mrs. Anna Schaefer in 1889. In 1894 the house was sold to newlyweds James and Fanny Baume. Judge Baume, a judge of the circuit court, was a widower with two children when he married Fanny. He came to Galena to begin his law practice in 1879 and "rapidly gained respect." (Photo Mueller Collection.)

HOUY HOUSE (FACES SOUTH PROSPECT STREET): 311 HILL STREET. William Houy, who owned the Houy House hotel in the first block of Hill Street for over 40 years, built his Queen Anne dream house in 1900. In 1895, William married Lizzie Caille, the daughter of ex-mayor George Caille, and this became their home. Although the address is on Hill Street, the circular tower, Victorian details, and wrap-around porch are visible from South Prospect Street. The Gothic influenced stairs from Prospect to Hill Streets were built in 1931 by the city. (Galena Historic Sites Office.)

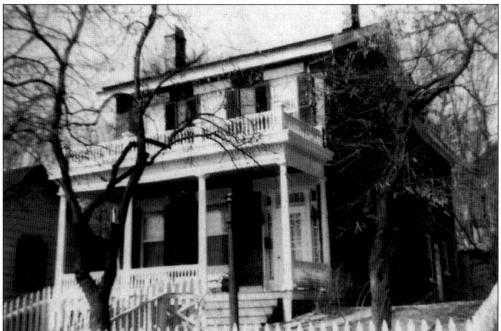

JOHN H. HELLMAN HOUSE: 108 NORTH PROSPECT STREET. Arriving in America from Germany at the age of 11, John H. Hellman came to Galena in 1842 and worked as a miner. Two years later, he went into the grocery business with J.A. Burrichter under the name Burrichter and Hellman. He built this substantial brick house in 1854. In 1900, he was listed as a capitalist, and in 1914, both he and his son, John V. Hellman, are listed as being in the farm mortgage business at 204 Main Street. (Photo McDermott Collection.)

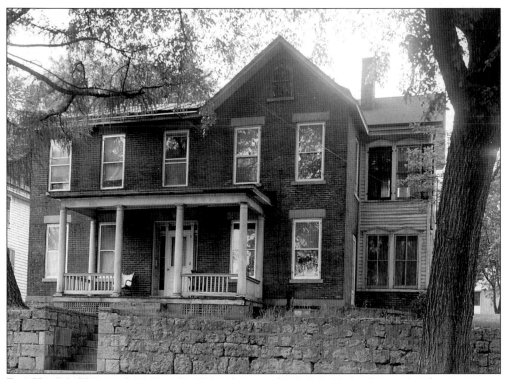

DR. KITTOE HOUSE: 105 SOUTH HIGH STREET (ABBEY'S HIGH STREET). The Dr. Kittoe House looks forlorn and forgotten in this 1964 photo. It had been divided into four apartments and was in a dilapidated condition. The present owners bought the house in 2002 and restored it as a bed-and-breakfast inn. Dr. Kittoe was an avid horticulturist, and the new owners created a luxurious formal garden, complete with gazebo, using old photos of Dr. Kittoe's garden. (Photo Galena Historic Sites Office.)

DR. KITTOE. Edward Kittoe, who was born in England in 1814, came to the United States where he studied medicine. He moved to Galena in 1851 and opened his practice. Dr. Kittoe entered the Civil War in 1861 as a volunteer surgeon and left it as a brevetted colonel in 1865 after serving as medical director on Grant's staff. Dr. Kittoe returned to Galena after the war and settled in this house. Undoubtedly, Grant must have visited his old friend here. (Photo Mueller Collection.)

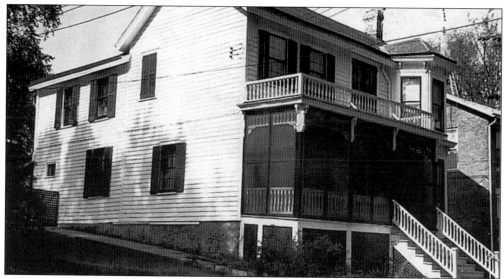

GRAHAM HOUSE: 109 SOUTH HIGH STREET. The photo above, taken in 1964, shows us that the present lively Victorian paint scheme and the removal of the screens on the porch have made a substantial improvement to the building's appearance. Ebenezer Graham, who built the house in 1857, owned a furniture dealership. It was probably Judge William Spensley that added the Victorian porch and bay window, after taking occupancy in 1885. Born in England, he came to Galena to study law and was elected Judge in 1872. (Photo Galena Historic Sites Office.)

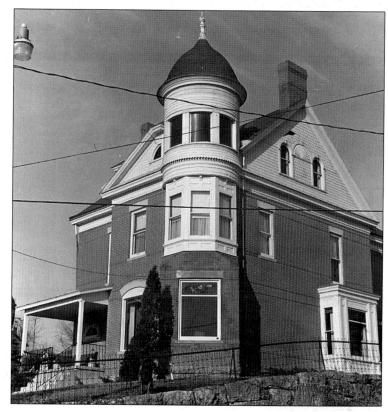

JOHN V. HELLMAN HOUSE: 318 HILL STREET. Visible from most of Galena and facing Prospect Street, the elegant Queen Anne mansion of John V. Hellman was built in 1898. One of six children of John H. Hellman, who lived close by on Prospect Street, John V. joined his father in the grocery business in 1882, after working for the Burrichter Bros. for 12 years. He was married to Wenona, the daughter of Captain Daniel Harris. (Photo Galena Historic Sites Office.)

GRANT'S PRE-CIVIL WAR HOME: 121 SOUTH HIGH STREET. John Robinson, builder of several rental properties in Galena, constructed this house in 1859. He also owned a farm and had a lime burning business on Spring Street. A year later, the house gained a prominent place in history when Ulysses and Julia Grant rented the house upon arrival here. He came to Galena to work with his brothers in the Grant and Perkins Leather Shop. Grant trained troops in Galena, and in July 1861 was promoted to brigadier-general by Lincoln. (Photo Galena Historic Sites Office.)

ST. MATTHEW'S LUTHERAN CHURCH: 125 SOUTH HIGH STREET. Organized in September of 1858, St. Matthew's congregation built this classic Gothic Revival building in 1863 at the cost of $3,500. In 1874, the roof was blown off during a tornado. When it was rebuilt, an additional 25 feet were added to the back. The first pastor, Rev. John Klindworth, served the congregation for over 40 years. His funeral, shown here, took place in 1907. (Photo Mueller Collection.)

WILLIAM FIDDICK HOUSE: 129 SOUTH HIGH STREET. William Fiddick, a successful Galena merchant, was the first owner of this graceful and spacious Greek Revival home in 1858. The formal parlour features the original large and intricate medallion, marble fireplace, and gilded carved pier mirror and valances. Born in England, William came to Galena in 1835 and went into the mercantile business. He was also a director of the Galena Woolen Mills. (Photo Galena Historical Museum.)

HIGH STREET 100 BLOCK. Louis Neubert shows off his classy 1915 roadster. This photo was taken in the 100 block of High Street. In the background is the 1840s frame cottage built by Hannah Duncan in 1844 and the Ebenezer Graham House, constructed in 1857. (Photo Mueller Collection.)

STRODE HOUSE: 209 SOUTH HIGH STREET. Originally built by Mary Strode in the Greek Revival style in 1852, this elegant house was remodeled in 1892 with a three-story square tower and wing with a two-story bay on the north side. In 1869, Richard Fiddick, who was in the dry goods and mercantile business, bought the house. He helped establish the Peoples Bank in 1883. The house has been tastefully restored. (Photo Mueller Collection.)

BENNETT HOUSE: 211 SOUTH HIGH STREET. Charles Bennett, who built this charming brick home in 1846, owned a lot of property in this county. Stewart Crawford, owner in 1852, was a partner with his brother in the drug store business. Beginning as a small one-and-a-half story brick home, the house has seen five expansions. The first was the raising the roof to a full two stories. The last two expansions were accomplished by the present owners and include a dramatic classical English conservatory and a two-story family room wing. (Photo Kirkby and Palmer Collection.)

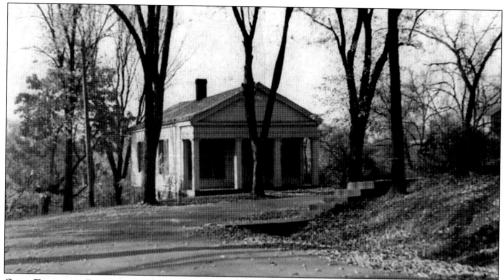

ODD FELLOWS LODGE: 229 SOUTH HIGH STREET. Ionic capitals accent the Greek Revival building built in 1841 for Wildey Lodge No. 5 of the Odd Fellows organization. Originally on Prospect Street, it was moved to its present location in 1871 and sold to the Peter Lehnhardt family. The building was in their family for over 80 years. Peter was a miner. Wildey Lodge was named for Thomas Wildey who founded the Odd Fellows in America in 1819. The local chapter was established in 1838. (Photo Mueller Collection.)

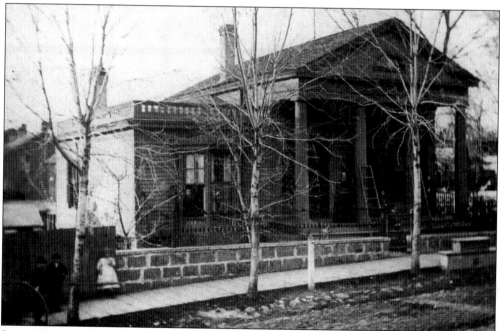

SCOTT-FOWLER HOUSE: 219 SOUTH HIGH STREET. Resembling a classic Greek temple, the Scott-Fowler house was built in 1843 by Charles Scott, who worked as a plasterer. Dr. Benjamin Fowler, a local physician, purchased the house around 1860. Active in local affairs, he served on the city council in 1872, 1873, and 1875. He is remembered for commanding the cavalry during the Grant Birthday Celebration Parades. (Photo Mueller Collection.)

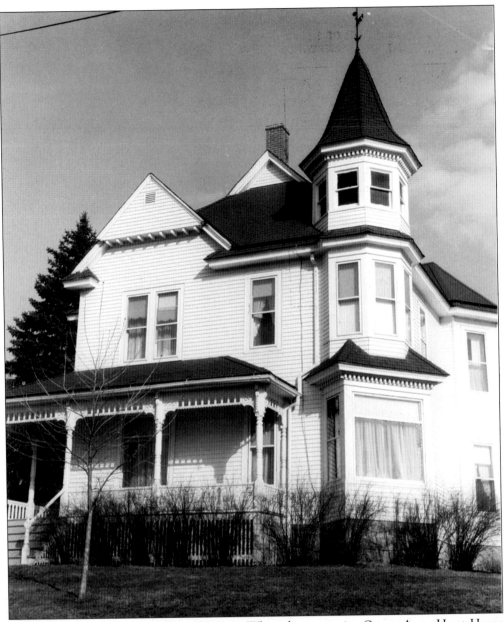

HURST HOUSE: 226 SOUTH HIGH STREET. When the impressive Queen Anne Hurst House was built in 1893, it was described in the *Galena Gazette* as "a spacious ten room house in the Moorish style of architecture with porches and a corner turret. It is equipped with a complete water system and is heated by hot air." William Hurst owned the Hurst Clothing Store, which offered mens, boys, and youth clothing and overcoats. (Photo Galena Historic Sites Office.)

SOURCES

Jo Daviess County County Courthouse: 330 N. Bench St.
 Deed books, Mortgage Records, Birth and Death Certificates, Wills
Galena Historical Society and Museum: 211 S. Bench St.
 Archives contain historic photographs, directories, history books, memorabilia
Alfred Mueller History Room, Galena Public Library: 601 S. Bench St.
 Assessor's Books: A few from 1830s, 40s, and 50s, 157 to 1890
 City Directories: 1848, 1847–48, 1854, 1858, 1868, 1873–74, 1900, 1914, 1953
 Telephone Directories: 1924–1950
 Historic Home Tour Records
 Church Records
 The History of Jo Daviess County, 1878
 Portrait and Biographical Album of Jo Daviess County, Illinois, 1889
 Newspaper files 1828 to present: *Galena Daily Gazette*, *Miner's Journal*, *Galena Advertiser*
 Local history books
 Birth, marriage, death records
Illinois Historic Sites Office: Route 20 at 4th St.
 Alfred Mueller Historic Photo Collection
 Materials about Grant
 Files on houses and photos of houses in the 1964 historic sites survey
Old Market House: 123 Commerce St.
 General Grant Exhibit

INDEX